POSTCARD HISTORY SERIES

Belle Isle

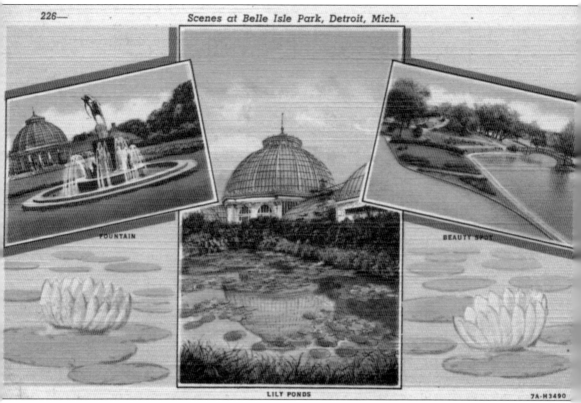

Scenes at Belle Isle Park, Detroit, Mich.

SCENES AT BELLE ISLE PARK. Belle Isle is home to many sightseeing venues and athletic and leisure activities and serves as a peaceful respite from the busy nature of city life. This souvenir card features the Levi Barbour Fountain and lily ponds at the Anna Scripps Whitcomb Conservatory and a Belle Isle "beauty spot" featuring the once familiar gathering spot known as the Cedar Mound. (Authors' collections.)

ON THE FRONT COVER: STROLLING THE AVENUE. Wide, tree-lined Central Avenue was part of famed landscape architect Frederick Law Olmsted's design for Belle Isle as the promenade for Detroiters and Windsorites to meet and socialize. It also would have been the place to "people-watch" and view the latest fashion worn by local members of society. (Authors' collections.)

ON THE BACK COVER: SAILING AT THE BOAT CLUB. Established in 1839, the Detroit Boat Club is the oldest boat club in America. The club moved onto Belle Isle in 1889 and endured two clubhouse fires: one in 1893 and another in 1901. The current clubhouse was dedicated on August 4, 1902, and continues to host boating and non-boating activities for its members. (Authors' collections.)

POSTCARD HISTORY SERIES

Belle Isle

Karen MacArthur Grizzard and Ericka L. Grizzard

ARCADIA
PUBLISHING

Published by Arcadia Publishing
Charleston, South Carolina

Printed in the United States of America

Library of Congress Control Number: 2017930451

For all general information contact Arcadia Publishing at:
Telephone 843-853-2070
Fax 843-853-0044
E-mail sales@arcadiapublishing.com
For customer service and orders:
Toll-Free 1-888-313-2665

Visit us on the Internet at www.arcadiapublishing.com

This book is dedicated to our family, past and present,
in honor of our deep Detroit roots.

CONTENTS

ACKNOWLEDGMENTS

The authors would like to take this time to acknowledge those who have encouraged us to pursue our passion for history and genealogy. Special thanks go to Lauren Grizzard, Ian Wilson, Ron Grizzard, Briana MacArthur, Christopher MacArthur, Dr. Pamela C. MacArthur, Nancy MacArthur Karvellas, and Randall G. MacArthur for their continued love and support. Unless otherwise noted, all images are from the authors' collections.

INTRODUCTION

Belle Isle is a nearly 1,000-acre unique island haven filled with old-growth forest and scenic lake and river landscapes near the heart of urban and industrialized Detroit. Located on the Detroit River, one of the busiest international shipping lanes in the world, between Detroit, Michigan and Windsor, Ontario, Canada, the island has played host and entertainer to Detroiters, Windsorites, and guests for over a century.

The Chippewa, Huron, Miami, and Ottawa Indians had occupied the land surrounding Detroit and Belle Isle for hundreds of years before Europeans settled the area, and they referred to Belle Isle as Wahnabezee, or "Swan Island." When French explorer Antoine de la Mothe Cadillac first founded Detroit on July 24, 1701, as Fort Pontchartrain du Détroit, it is said that he used his power as commandant to grant the island to the village for use as a common. The French settlers first called the island Isle au Cochon, or the more unflattering English translation, "Hog Island." It was a widely held belief that hogs were put on the island to kill a rampant snake population, but the more likely reason is that an island proved a perfect place to confine hogs, cattle, and other village livestock in order to keep them from roaming away, destroying crops, or being killed or stolen.

The British government took control of Fort Detroit after the French were defeated at Montreal, Quebec, Canada, during the French and Indian War. Fort Detroit, which was a stronghold during the war, and its surrounding area was passed to the command of British major Robert Rogers and his men in November 1760, and for a few years, the island remained as it had been—filled with livestock and cultivated by a few farmers under the supervision of the fort's commander. After the land officially transferred to the hands of the British in 1763, questions were raised about who held the land grant for Hog Island. Several petitions were made to King George III for individual land grants, but Lt. George McDougall was the eventual successful recipient.

In 1762, McDougall had built a house and cleared land on Hog Island, and given his meritorious service to the crown during Chief Pontiac and the Ottawa tribe's siege of Detroit in 1763, McDougall had a favorable edge over the other petitioners. The king's council informed McDougall that he could remain on the island so long as it was beneficial to the fort, but that no grant could be given without consent of the local tribes, so McDougall, at his own expense, gathered the chiefs of the Chippewa and Ottawa Indians to ask for conveyance of the land through deed. He bought the land from the Native Americans in 1769 for eight barrels of rum, three rolls of tobacco, six pounds of vermilion paint, and a wampum belt (wampum referred to small white and purple beads made of whelk or quahog shells that were used for decoration and as money). His purchase of the island totaled approximately 194 British pounds at that time.

At the end of the Revolutionary War, the 1783 Treaty of Paris directed that Michigan become part of the new United States of America; however, the British refused to surrender Forts Detroit and Mackinac until 1796. As the area passed into the control of the new American government, questions about ownership of the island were again raised. Lt. George McDougall had died during the intervening time, and the island, though disputed, was still in the possession of his widow and sons. However, the new US Congress decided to ignore any grants made prior to July 1, 1796, and the island was once again up for grabs. Possession of the island went to brothers John, William, and David Macomb, and they occupied the island until financial difficulties and estate complications forced them to sell the land to Barnabas Campau for $5,000 in March 1817. The Campau family possessed the island until the City of Detroit bought it in 1879 to be used as a public park.

While the Campau family privately owned Hog Island, it found increased usage by many members of the public. It was used as a picnic ground, a dueling ground, and notably as a place of quarantine that began Detroit's devastating cholera epidemic in 1832. The steamer *Henry Clay* was passing through Detroit on its way to Chicago, and aboard were famed general Winfield Scott and a detachment of his soldiers. One of the soldiers became ill with cholera and died within a few hours. Other soldiers on board became sick within a short amount of time, and the *Henry Clay* was ordered to proceed to Hog Island, where supplies would be sent to aid them. Seven soldiers died at Detroit, and two of the individuals sent to liaise with the steamer also became ill —one died in the city, while the other recovered. The *Henry Clay* only stayed long enough to procure needed supplies, but the damage was done. Cholera spread to epidemic proportions in Detroit and at the steamer's stops in Mackinac, Michigan, and Chicago, Illinois.

As the popularity of the island grew as a picnic and recreational ground, the Campau family found a way to produce revenue by establishing accommodations and a ferry company to transport visitors. In July 1845, a large group of visitors came to the island and called a meeting to change the 145-year name of "Hog Island" to something more fitting of a destination place. The widely held belief is that it was named Belle Isle to honor Isabelle Cass, daughter of former Michigan governor Lewis Cass, although to avoid the appearance of naming it for one individual the alternative idea has been presented that the word *belle* speaks for itself, as it means "beautiful." The name change passed the meeting unanimously, although questions remains as to whether Campau was aware or gave consent to the change.

By 1879, the city of Detroit was growing rapidly and the small parks dotting the urban area did not provide enough space for the population to enjoy fresh air and breathing space. Citizens came back from travels abroad discussing large public parks and wide boulevards they had seen in places like Paris, France, and a resolution was sent to the city council about buying up large plats of land for the creation of a large park. Belle Isle was soon purchased from the heirs of Barnabas Campau, famed landscape architect Frederick Law Olmsted was hired, and construction of Detroit's crowning jewel commenced.

One

The Fun of Getting There

Early visitors to Belle Isle did not have many options for accessing the island. Prior to the completion of a bridge, ferryboats or small vessels were the only ways of getting there. Once the bridge was in place, visitors walked, bicycled, or rode in carriages. As Detroit's automobile industry advanced, more people were able to afford personal transportation in the form of the automobile and began enjoying the sport of motoring. When recreational or leisure time became more prevalent in society (thanks in part to the Industrial Revolution's changes in the way work was completed and time was structured), Belle Isle's attraction to the public increased as a place to get away from the bustle of the city and enjoy the outdoors. With a wide range of activities available, the island became a major destination, but everyone knows that part of the fun of any outing is the fun of getting there.

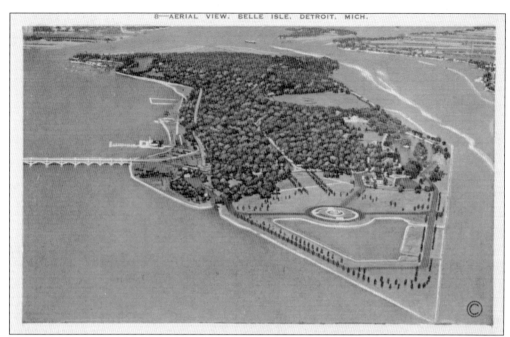

AERIAL VIEW OF BELLE ISLE. Situated between Detroit, Michigan, and Windsor, Ontario, Canada, Belle Isle has been an international playground for Detroiters and Windsorites since the 1880s. Belle Isle was purchased by the City of Detroit in 1879, and the park had a formal opening ceremony on May 10, 1880.

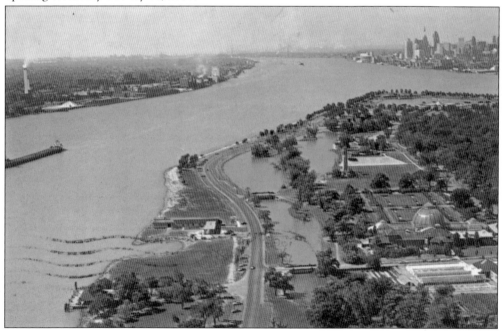

VIEW OF BELLE ISLE, 1960s. This aerial view from the 1960s depicts the southwestern tip of Belle Isle, with Windsor to the left, the Detroit skyline to the right, and the Ambassador Bridge in the background. Located in the Detroit River, Belle Isle greets passing ships on one of the world's busiest international waterways.

10

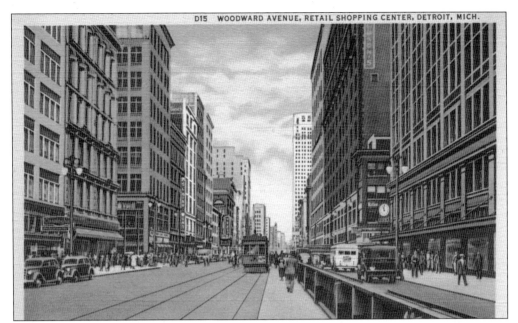

SHOPPING IN DOWNTOWN DETROIT. Detroit's rapid growth in the late 1800s and early 1900s provided opportunities for businesses large and small to capitalize on the needs of an ever-growing population. Lined with exclusive shops and large department stores, Woodward Avenue became one of the busiest retail shopping centers in Detroit. Retailers provided a large array of shopping opportunities for Detroiters.

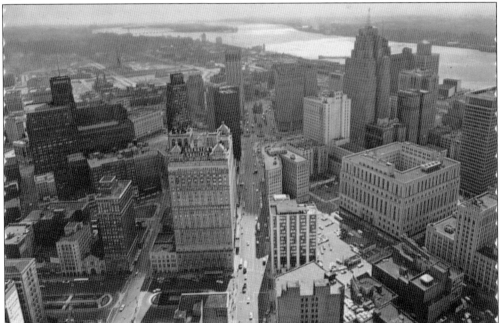

MICHIGAN AVENUE, VIEW LOOKING EAST. This 1960s-era view from the heart of Detroit at Michigan Avenue and Washington Boulevard shows the proximity of Belle Isle to downtown districts. This cityscape features (near top left) the J.L. Hudson's Department Store, the Book-Cadillac Hotel (foreground), and the Penobscot Building (upper right corner).

11

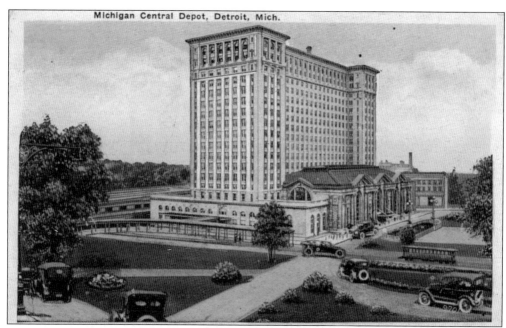

Michigan Central Depot, Detroit, Mich.

RIDING THE RAILS. Owned by the Michigan Central Railway, which spared no expense in providing a modern facility and ample amenities for its numerous passengers, Michigan Central Station served as the major hub for travelers coming to Detroit. Formally dedicated on January 4, 1914, it had opened earlier in 1913 due to the fact the older station had been destroyed by fire.

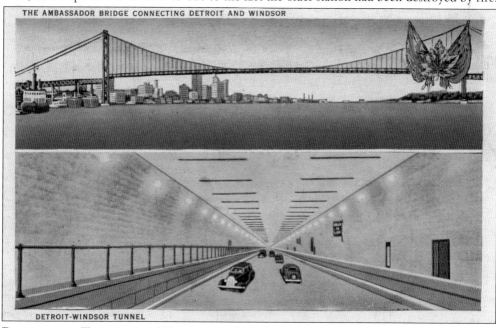

THE AMBASSADOR BRIDGE CONNECTING DETROIT AND WINDSOR

DETROIT-WINDSOR TUNNEL

BRIDGE AND TUNNEL, C. 1938. Detroit hosts two international border crossing stations connecting the United States to Windsor, Ontario, Canada, both above the surface and below the nearly mile-wide Detroit River. The Ambassador Bridge opened to motorists on November 15, 1929, while the Detroit-Windsor Tunnel was dedicated by US president Herbert Hoover nearly a year later and formally opened on November 3, 1930.

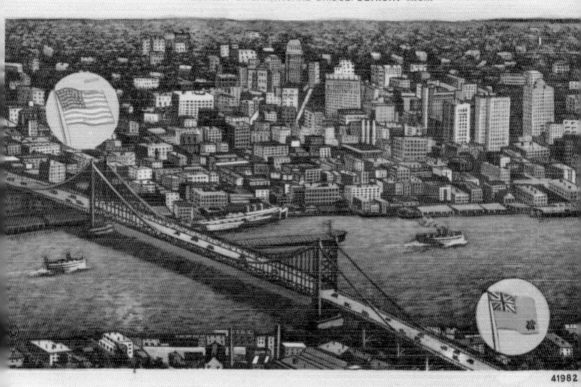

41982

INTERNATIONAL BORDER CROSSING, C. 1948. Prior to the construction and opening of the Ambassador Bridge, international travelers had to be ferried across the Detroit River. Plans for a bridge did not come to fruition until John W. Austin approached Detroit financier Joseph A. Bower about a contract to paint a bridge should one ever be built; from there, the two spearheaded the bridge project and acquired the necessary financing. Detroit's mayor at the time, John Smith, opposed a privately owned bridge, but voters, in a special election, overwhelmingly approved the project on June 28, 1927. Architect Jonathan Jones designed the 7,490-foot Ambassador Bridge in the popular Art Deco style of the 1920s with a nod to Gothic-style elements, and the McClintic-Marshall Company of Pittsburgh, Pennsylvania, undertook the construction. At the time of its opening, the bridge was to be the longest suspension bridge in the world, a title held for two years until it was surpassed by New York's George Washington Bridge in 1931. Today, the bridge remains the world's longest international suspension bridge.

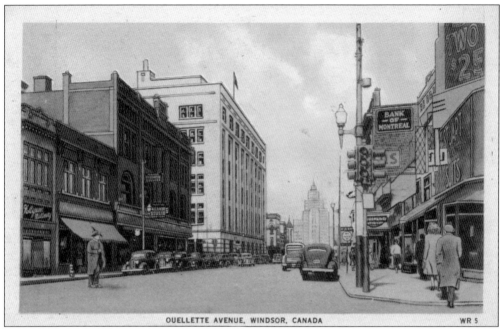

OUELLETTE AVENUE, WINDSOR, CANADA WR 5

WINDSOR, ONTARIO, CANADA. Located directly across the river from Detroit is the city of Windsor, the southernmost city in Canada. The two cities serve as international ports of entry and share a rich history of growth in the auto industry. Residents of one city often worked in the other, lending to the economic growth of both countries. During Prohibition in the 1920s and 1930s, Windsor became a major supplier of "liquid refreshment" to the United States. Rumrunners often used Belle Isle as a connection point between the countries. An article dated April 14, 1929, in the *Detroit Free Press* reports that an Inspector Berg may have been "guilty of neglect in properly checking up on reports" from his patrolmen stationed on Belle Isle regarding possible illegal alcohol deliveries.

Birds Eye View looking West. Windsor. Canada.

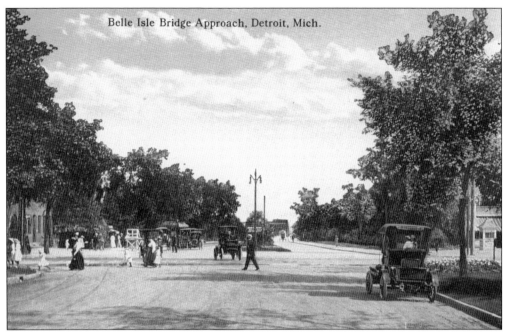

Belle Isle Bridge Approach, Detroit, Mich.

BELLE ISLE BRIDGE APPROACH. The Bridge Approach encompassed the areas of land at either side of the bridge. According to the *Annual Report of the Department of Parks and Boulevards, City of Detroit*, dated July 1, 1911, the Belle Isle Bridge Approach at Jefferson Avenue totaled 1.02 acres and was valued at $120,000. The report recommends that the city not delay in acquiring adjoining property south of Jefferson Avenue and the corners on the north side. It is noted that this land would be needed if a new bridge were to be built and points out the inadequacy of the present structure, citing extreme traffic on Sundays and holidays as posing a danger. It is recommended that a new bridge be taken under consideration at once.

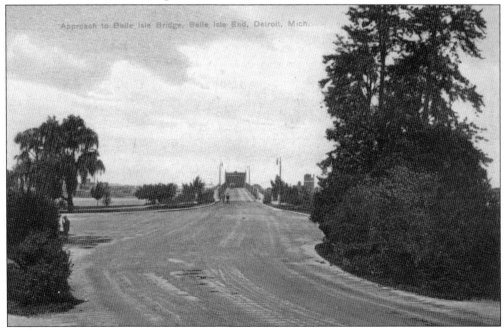

Approach to Belle Isle Bridge, Belle Isle End, Detroit, Mich.

15

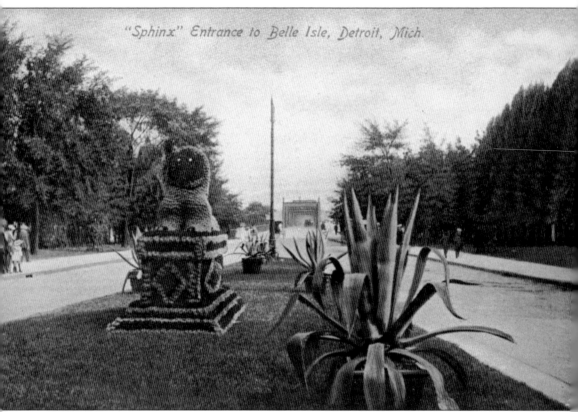

"Sphinx" Entrance to Belle Isle, Detroit, Mich.

RELIC OF DAYS OF PHARAOH CLEVERLY DONE IN FLOWERS. Half man and half lion, the ornamental monument of the sphinx guards the Belle Isle Approach on the Jefferson Avenue side of the bridge. The *Detroit Free Press* features the sphinx in an article dated Sunday, July 1, 1906, declaring that "one no longer had to journey across the hot sands of distant Egypt to interview the Sphinx. One simply had to ride out to the Eastern Boulevard, trek one hundred feet southward across the blistering asphalt, and the sphinx is before you in all its majesty." The creation of the sphinx was credited to park commissioner Philip Breitmeyer and Supt. William Dilger and was the crowning jewel of the decorative scheme planned for city parks that year. Philip Breitmeyer was a florist and one of the founders of Florists' Telegraph Delivery (FTD); he later served as mayor of Detroit from 1909 to 1910.

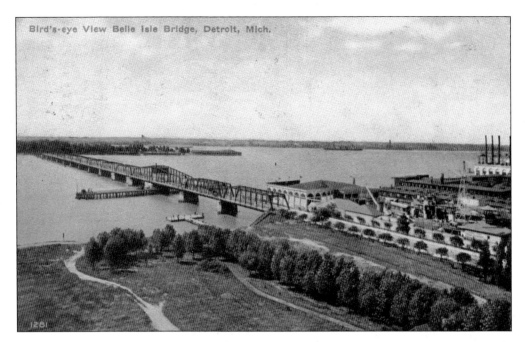

Bird's-eye View Belle Isle Bridge, Detroit, Mich.

OLD BELLE ISLE BRIDGE. The idea of a bridge was first proposed in February 1885 and a resolution was adopted in December of that year by the city council. Land was secured soon afterwards. Plans and specifications were approved in February 1886, and construction began in September 1887. The wood-and-steel swing bridge was completed in June 1889 at a cost of about $295,000. Just 8 feet shy of being one mile long and about 45 feet wide, it included twelve 156-foot through spans, one 318-foot swing span, and five 88-foot pony truss spans, with plank floors and timber stringers. Later, it was paved with creosote block.

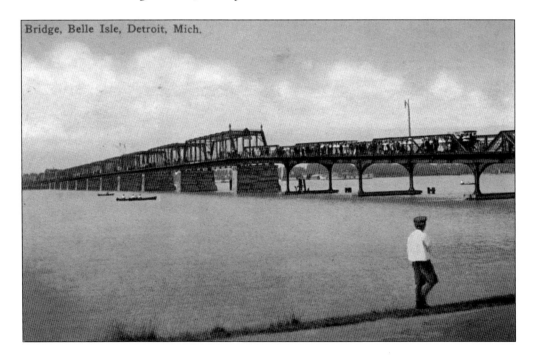

Bridge, Belle Isle, Detroit, Mich.

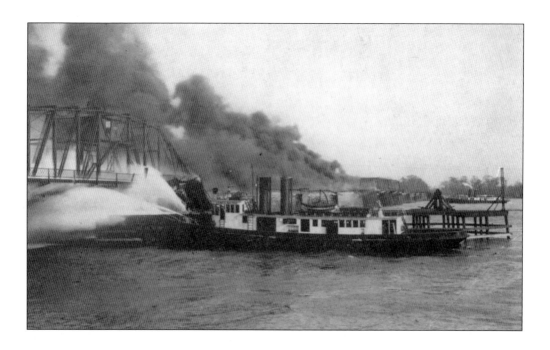

BURNING BRIDGES. At a little after 3:00 p.m. on April 27, 1915, the alarm went out that the Belle Isle Bridge was on fire. Reportedly, a Detroit Public Works tar wagon had passed over the bridge, and hot cinders from its firebox were believed to have sparked a fire that rapidly engulfed the wood-and-steel structure. The heat was so intense that it twisted the steel and caused some of the stone piers to split and crumble into the river. Two fireboats and 13 fire departments worked to put out the flames, but they were unable to save the bridge.

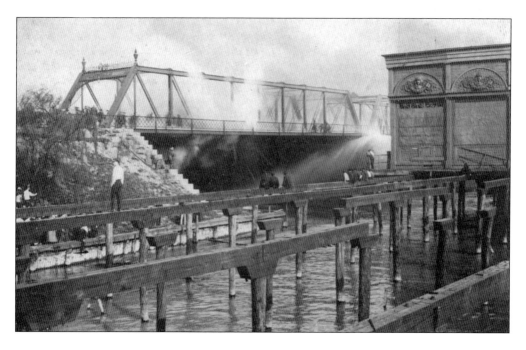

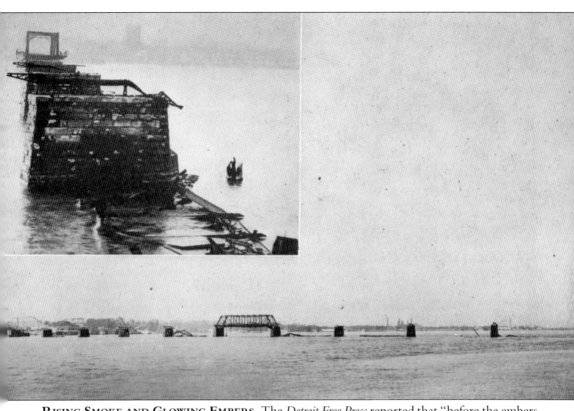

RISING SMOKE AND GLOWING EMBERS. The *Detroit Free Press* reported that "before the embers of the bridge ceased to glow and while smoke was rising from the charred remains, the common council took the first steps toward the erection of a new structure." Mayor Oscar Marx and secretary Edward T. Fitzgerald "braved the streams of water from the fire boats and from firemen working beneath the bridge and walked to the end of the draw, which was already creaking and groaning before it fell. Despite the fact that he was drenched with water and spotted with soot . . . the mayor stood at the end of what was left of the bridge and watched the fire boat crews in their futile fight to save the structure." He remarked that it looked like a war scene and that the next bridge would be built from concrete and made absolutely fireproof.

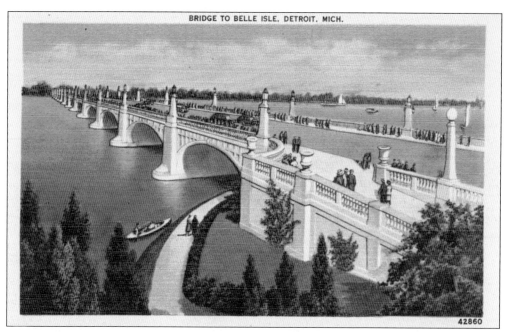

42860

THE NEW BELLE ISLE BRIDGE. After eight years, Mayor Oscar Marx and Detroit's common council got their new fireproof concrete bridge connecting Detroit and Belle Isle. Built under the supervision of Detroit's Department of Public Works, the new Belle Isle Bridge opened on November 1, 1923, at a cost of just over $2.5 million. At 85 feet wide with 12 feet of sidewalk on either side of the roadway, the new concrete and steel structure featured 19 arches and spanned 2,193 feet, with a clearance of 30 feet above the water so that it was tall enough for boats to pass underneath. Originally named the George Washington Bridge, it was renamed the Douglas MacArthur Bridge in 1942.

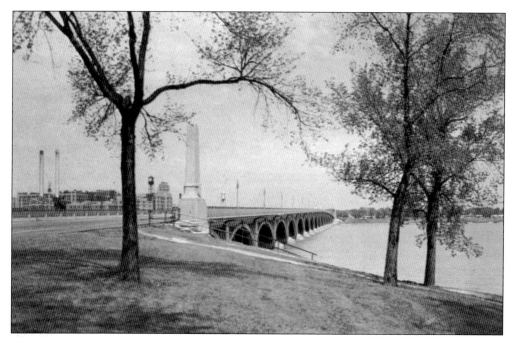

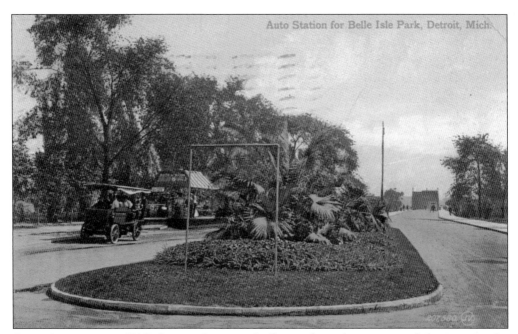

AUTO STATIONS, C. 1909. Auto stations were built near the park entrance and also near popular island attractions such as the casino and the bathhouse to transport visitors across the bridge and to their desired destinations around the island. The magazine *Park and Cemetery and Landscape Gardening* reports in its February 1912 issue that two auto busses for conveying passengers across the bridge to Belle Isle proved to be not only popular, but also a wise decision. The busses were put into use on February 17, 1912, and by June 30, 1912, they had carried 90,219 passengers and covered a distance of over 11,000 miles. Island visitors were able to ride the busses or one of the contracted Belle Isle Auto Company's nine vehicles for the small fee of 15¢, while park employees had a discounted rate of 1¢.

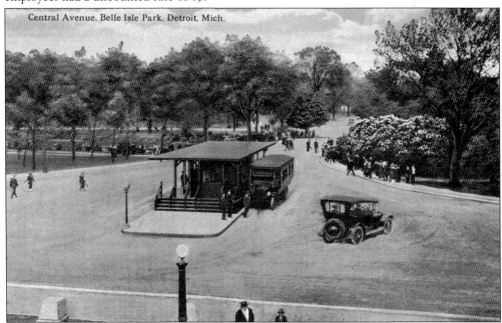

21

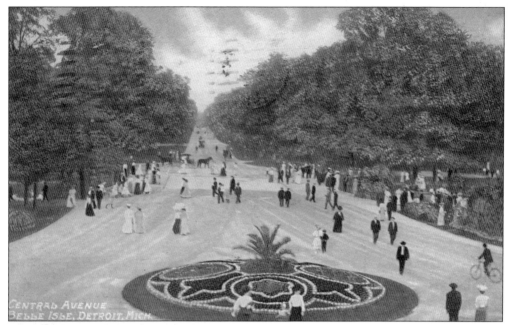

THE PLACE TO SEE AND BE SEEN. Central Avenue's early purpose was to serve as a grand boulevard providing a social gathering place for a leisurely stroll with friends, family, or that special someone and then branch out to various island venues. Special attention was given to landscaping with elaborate flowerbeds, shrubs, and trees, although Frederick Law Olmsted's true vision for the boulevard never came to fruition.

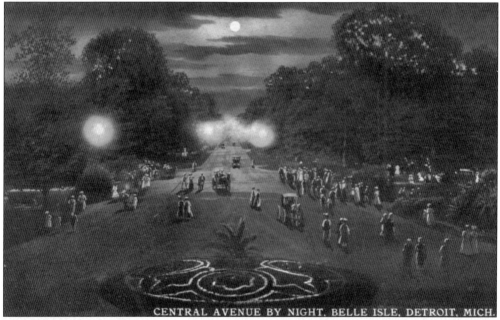

A MOONLIT VIEW. Nighttime on Belle Isle provided a respite from busy daytime activity. In the quiet of the evening, guests could enjoy a leisurely moonlit stroll along the avenue or dinner and dancing at the casino or the yacht club, take a romantic canoe ride, or attend a concert at the pavilion.

DRIVE WAY, BELLE ISLE, DETROIT, MICH.

ROADS TO ADVENTURE. While Central Avenue was Belle Isle's main thoroughfare, numerous roadways ran throughout the island providing ample space for pedestrians, bicyclists, horse-drawn phaetons, and automobiles to explore the park or enjoy rides along lush tree-lined drives and splendid river vistas. According to the 1911 *Annual Report of the Controller of the City of Detroit*, Belle Isle contained 5.5 miles of shoreline drive and 14.5 miles of roads throughout the interior of the park. Road maintenance for the same year included a cost of $16,095 for road resurfacing and $5,642 for oiling the roads.

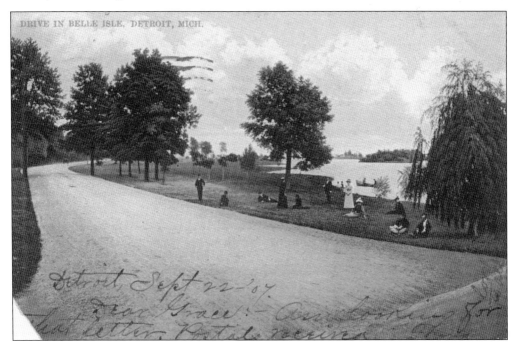

DRIVE IN BELLE ISLE, DETROIT, MICH.

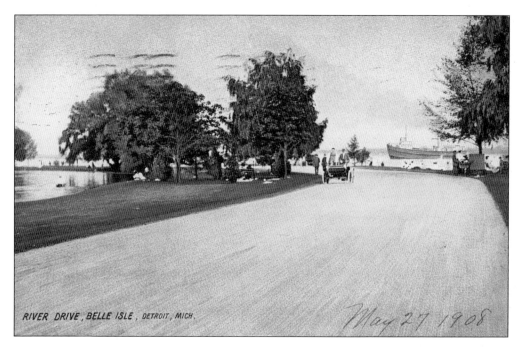

RIVER DRIVE, BELLE ISLE, DETROIT, MICH.

May 27 1908

WATCHING THE PASSING BOATS. From sailboats and canoes to passenger excursion steamers and cargo-laden freighters, river traffic has always kept a steady pace on the Detroit River. A favorite pastime for guests to the island was watching the numerous vessels venture up and down the waterway. Belle Isle's River or Shore Drive provided the perfect spot to enjoy the sights and sounds of life on the river while enjoying a picnic or lounging upon the lawn. River Drive was later renamed the Strand, and it follows the shoreline of the island from the southwest corner to the old lighthouse at the northern head of the island.

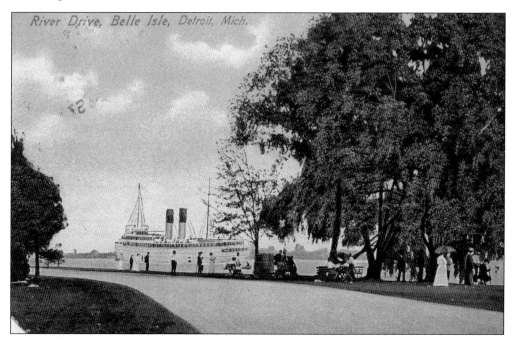

River Drive, Belle Isle, Detroit, Mich.

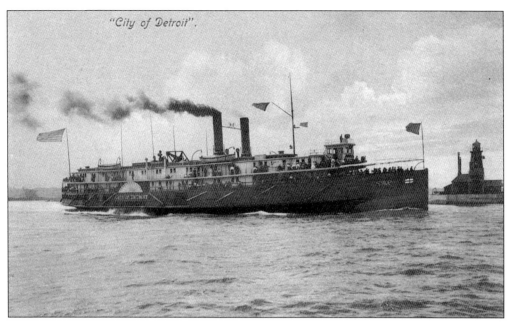

CITY OF DETROIT. Built in 1888 by the Detroit Dry Dock Company, the steamer *City of Detroit* was designed by Frank E. Kirby and owned by the Detroit & Cleveland Navigation Company. On March 31, 1891, she was grounded and sank in the Detroit River. After being raised and repaired at the Springwells Dry Dock, Detroit, she was back in use. In 1912, she was renamed the *City of Detroit II*.

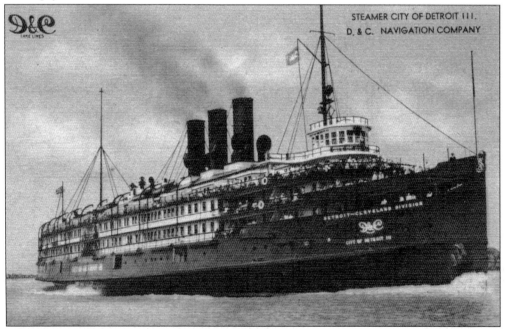

CITY OF DETROIT III. Designed by famed shipbuilder Frank E. Kirby, the steamer *City of Detroit III* (*D-III*) was launched from the Detroit Shipbuilding Company's Wyandotte yard on October 7, 1911, and was fitted out and ready to sail by May 30, 1912. The *D-III* came in at a cost of $1.5 million and rivaled ocean liners in her sheer beauty of design and interior craftsmanship.

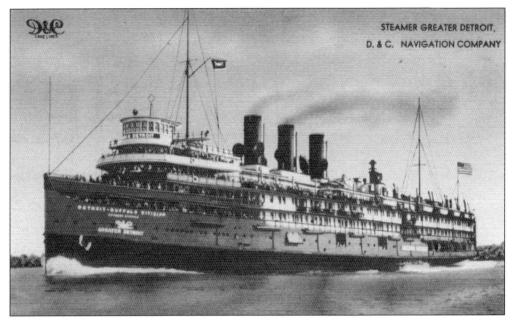

GREATER DETROIT. It took almost a year after her hull was launched in 1923 to complete the interior design, but the steamer *Greater Detroit* made a grand entrance to society on August 29, 1924, with her maiden voyage from Detroit to Buffalo. Nicknamed the "Leviathan of the Great Lakes," the *Greater Detroit* came with a price tag of $3.5 million.

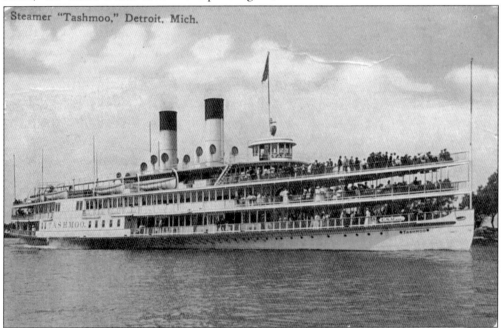

Steamer "Tashmoo," Detroit, Mich.

TASHMOO. Another Frank E. Kirby design, the steamer *Tashmoo* took her maiden voyage June 9, 1900. The 306-foot vessel was part of the White Star Steamship Company of Detroit and sailed between Port Huron and Detroit with stops at Tashmoo Park on a daily basis. *Tashmoo* smashed into the Belle Isle Bridge in December 1927 and then met her final fate June 18, 1936, when she hit a rock and sank near Amherstburg, Ontario, Canada.

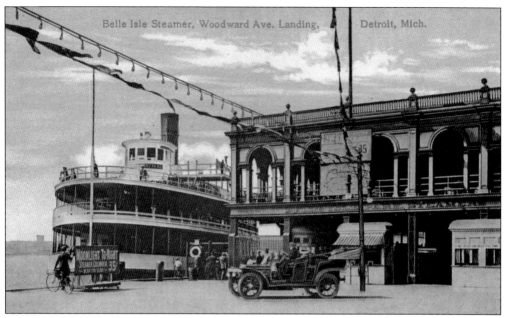

WOODWARD AVENUE FERRY DOCK. A favorite way for patrons to access the island was by steamer. The ferry landing at Woodward Avenue was operated by the Detroit Belle Isle and Windsor Ferry Company and made for a perfect location for Detroiters and visiting Windsorites to catch a steamer leaving every 15 minutes from downtown. Advertisements showcased afternoon and moonlit nighttime excursions for 35¢. Steamers stopped at various points along the Detroit Riverfront, at the piers on Belle Isle and Bois Blanc Island (Boblo Island), or made cruising excursions along Lake Erie, Lake St. Clair, and the Detroit and St. Clair Rivers. While waiting for their steamer, passengers could visit James Vernor's nearby soda fountain for Detroit's own Vernors Ginger Ale.

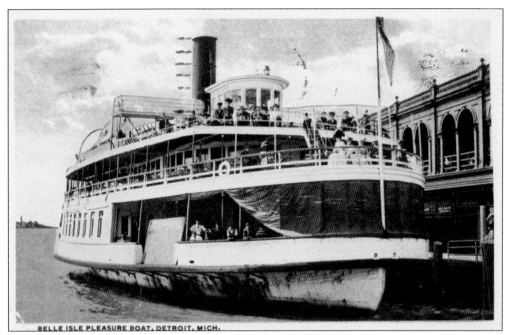

BELLE ISLE PLEASURE BOAT, DETROIT, MICH.

BELLE ISLE PLEASURE BOAT. Passengers lined the decks of the steamer *Promise*, which was the very first of the Detroit Belle Isle and Windsor Ferry Company's steamers to carry passengers from downtown Detroit to Belle Isle. *Promise* was designed by Frank E. Kirby and built and commissioned into service in 1892; it was joined in 1894 by the similarly designed *Pleasure*.

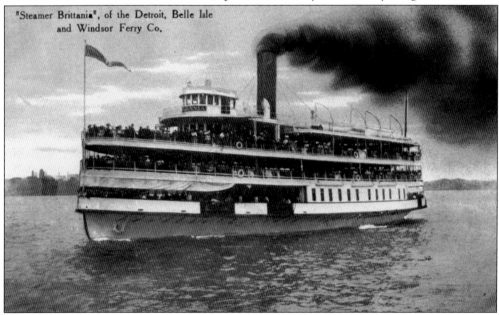

"Steamer Brittania", of the Detroit, Belle Isle and Windsor Ferry Co.

BRITANNIA. A new steamer was commissioned in January 1906 to alleviate high demand. The new steamer was to be named through a public competition, and on April 13, 1906, the *Detroit Free Press* announced the name *Britannia*. Winner J.G. Mullin received $10 in gold and a season pass on the company steamers. The *Britannia* was designed by Frank E. Kirby and built by the Detroit Shipbuilding Company. She entered company service in July 1906.

Two

ISLAND LEISURE ACTIVITIES

The great appeal of Belle Isle has always been its abundance of outdoor recreational space accessible without ever having to leave the city. As the population of Detroit boomed at the turn of the 20th century, Belle Isle became a necessary escape from the noisy crowds and industrial nature of the city. It was a place for citizens to simply spend the day filling their lungs with fresh air, or a place for social visits and entertainment that provided a respite from summer heat or a haven for winter sports. This chapter takes a look at the way Belle Isle visitors spent their leisure time.

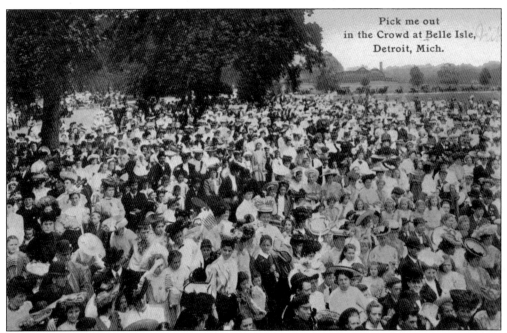

"PICK ME OUT IN THE CROWD AT BELLE ISLE." People flocked to Belle Isle to spend time outdoors with friends and family. Whether a planned event or an impromptu outing, Belle Isle hosted thousands of guests at any given time. Crowds swelled on the weekends to participate in sporting events, concerts, picnics, and various leisure activities.

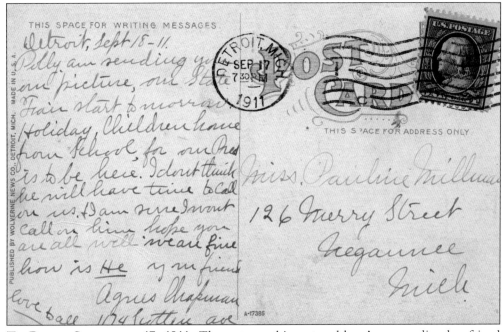

TO POLLY, SEPTEMBER 17, 1911. The note on this postcard has Agnes sending her friend Polly "their picture" in a crowd of people at Belle Isle. Her missive references that the Michigan State Fair was to begin the following day in Detroit, and area schools had scheduled a holiday in anticipation of Pres. William Howard Taft's address to the Michigan State Fair attendees.

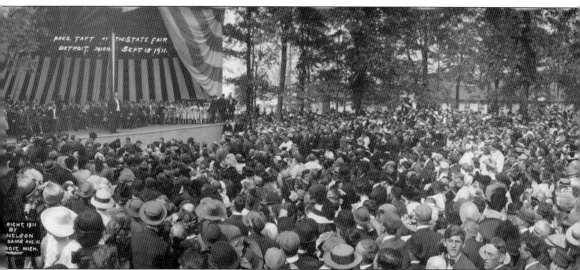

PRESIDENT TAFT AT THE STATE FAIR, DETROIT, MICHIGAN, SEPTEMBER 18, 1918. This image depicts the state fair event noted by Agnes Chapman in the previous postcard. This photograph shows the middle section of a panorama taken by Detroit-based camera operator turned filmmaker H.N. Nelson, featuring the event of Pres. William Howard Taft addressing the 1918 Michigan State Fair attendees. The *Detroit Free Press* reported on September 19, 1918, that President Taft was well-received with a "tremendous ovation" and spoke to a crowd of approximately 50,000 individuals at the fairgrounds on the subject of the importance of growing farms and agricultural education opportunities to meet the food supply demands of a growing US population. William Howard Taft was born in Cincinnati, Ohio, and served as the president of the United States from 1909 to 1913. (Library of Congress.)

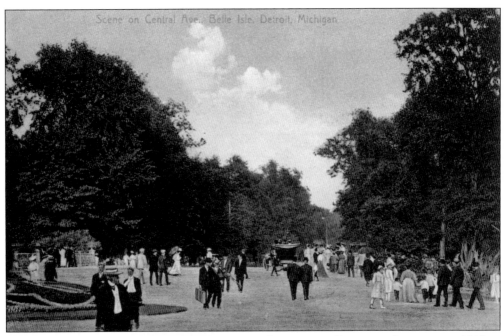

Scene on Central Ave., Belle Isle, Detroit, Michigan

SCENES ON CENTRAL AVENUE, C. 1910. Dressed in their finery for a stroll along Central Avenue, people enjoyed beautifully landscaped gardens, tree-lined walkways, and ornate bridges on the main promenade of Belle Isle. This postcard shows an array of the era's fashions, featuring men in various suit styles paired with derby and straw boater hats or plaid caps. Women chose dresses or blouse and skirt combinations with popular hats and parasols.

"LILLIAN KOHLMORGAN & ME AT BELLE ISLE." Two fashionable ladies pose for their photograph while on a leisurely outing to Belle Isle. On the back of this real-photo postcard is written, "Lillian Kohlmorgan & me at Belle Isle." Real-photo postcards became popular in the early 1900s when Eastman Kodak began selling the No. 3A folding camera, designed to produce postcard-sized prints.

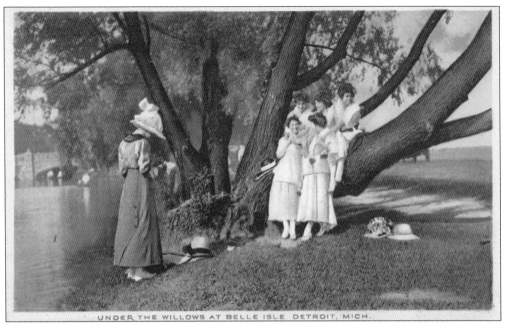

UNDER THE WILLOWS AT BELLE ISLE DETROIT, MICH.

UNDER THE WILLOWS. A group of young ladies poses for a photograph under the willow trees. The English willows planted in 1888 were presented to the park by commissioner Francis Adams. They were cut from the willows near Fort Wayne and were merely small shoots the size of an ordinary walking cane. They were planted by Supt. William Ferguson, in charge of the park at that time.

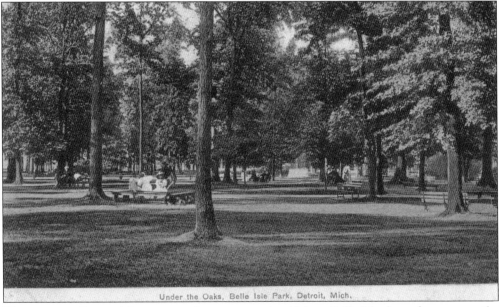

Under the Oaks, Belle Isle Park, Detroit, Mich.

UNDER THE OAKS. Many types of trees were plentiful on Belle Isle, but of note were the abundance and variety of oak trees under which parties enjoyed picnics and conversations on benches set out under the trees. The annual report of 1902 records the following on Belle Isle: "269 White Oak, 249 Swamp White Oak, 158 Pin Oak, 104 Red Oak, 80 Burr Oak, 11 Yellow Oak, and a single Scarlett Oak."

33

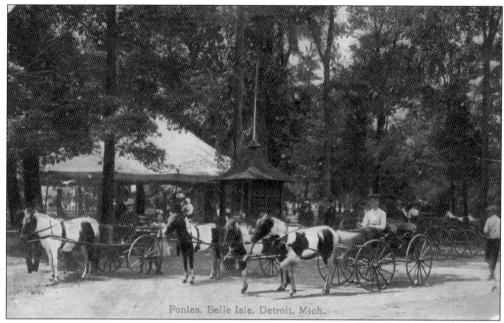

Ponies, Belle Isle, Detroit, Mich.

PONIES ON BELLE ISLE. Gilbert Watkins, of the Watkins Shetland Pony Farm in Birmingham, Michigan, began his pony ride concessions on Belle Isle in 1894. Pony carts and saddled ponies were extremely popular with guests who would pay 25¢ for an hour, 15¢ for a half hour, or 10¢ for a ride. The herd of ponies was imported from the Shetland Islands in the late 1880s to Watkins's 120-acre farm. He took great pride in breeding and maintaining the only herd to be registered in both the United States and the Shetland Islands. The pony concessions were operated by the Watkins family until 1960.

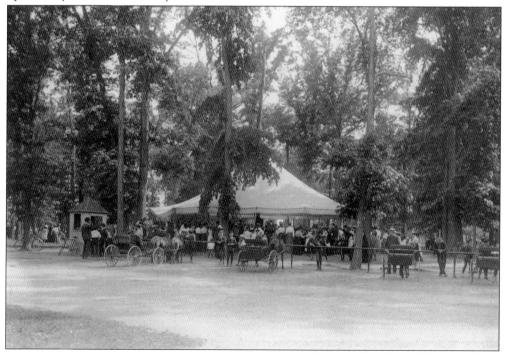

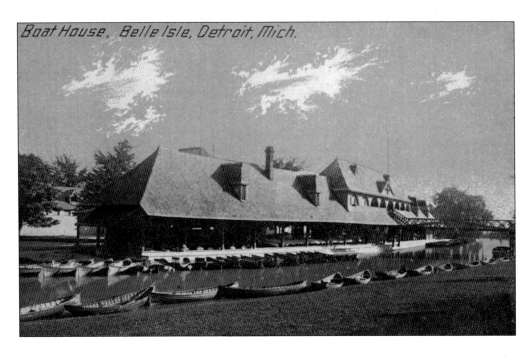

Boat House, Belle Isle, Detroit, Mich.

CANOEING THE RIVERS, LAKES, AND CANALS. Canoeing was another favorite activity for visitors to the island for many years. Guests could spend the day exploring the many canals, lakes, and rivers throughout the park, perhaps stopping for a picnic or paddling through the canal to the band shelter to enjoy one of the many concerts given daily throughout the summer. Canoe rentals proved profitable for many years. For the fiscal year ending in 1916, receipts totaled $17,037, with expenditures $5,839, thus providing a net profit of $6,198. Canoe rentals for the summer of 1929 increased to 41,850, up from the previous year's total of 38,276.

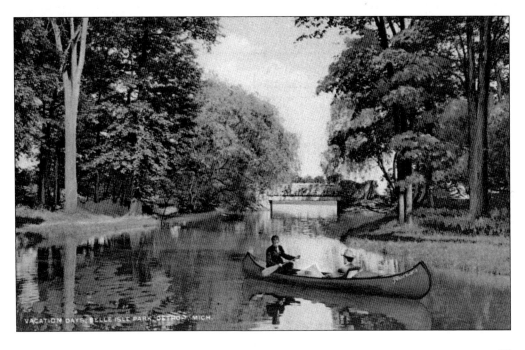

VACATION DAYS, BELLE ISLE PARK, DETROIT, MICH.

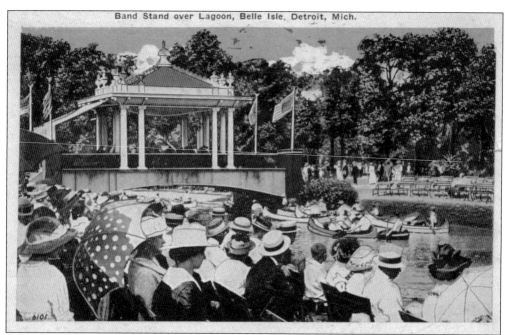

Band Stand over Lagoon, Belle Isle, Detroit, Mich.

SUMMER BAND CONCERTS. Band concerts were given twice a day during the summer months courtesy of the City of Detroit. Guests would gather on both shore lines or sit in canoes in the canal to listen to the band play. The summer season of 1903 came at a cost of $5,485, and by 1910, the concert budget was at $7,500. The *16th Annual Report of the Department of Parks and Boulevards, City of Detroit* (1907) states that "the music furnished . . . was looked upon by the people as a necessity, and on a summer evening the canal on Belle Isle park, which the band pavilion spans, might be likened to the canals of Venice, the exception being that canoes instead of gondolas are used, while the shores of the canal within hearing of the music are a surging mass of humanity."

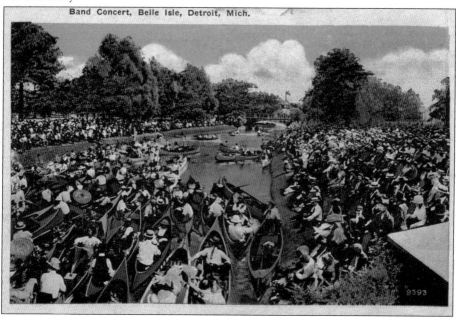

Band Concert, Belle Isle, Detroit, Mich.

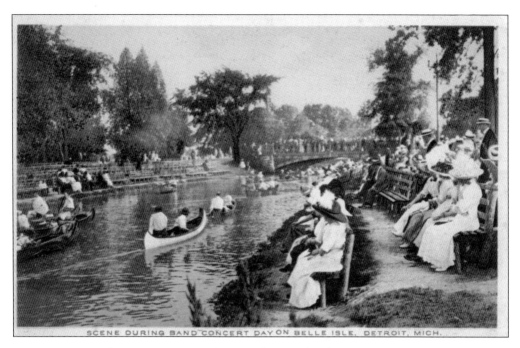

SCENE DURING BAND CONCERT DAY ON BELLE ISLE, DETROIT, MICH.

SCENES FROM A BAND CONCERT. The annual report for the year ending June 1899 from the commissioner of Parks and Boulevards gives a glowing report of a successful season in which the commissioner shared his vision for the open air concerts: "The open air band concerts are growing in favor and are enjoyed by many thousands of people, who congregate daily to hear them during the season, which is from June to September. . . . My aim is to have them varied to please all classes, but at the same time to have as high and elevating class of music as is consistent with the money allowed for the purpose."

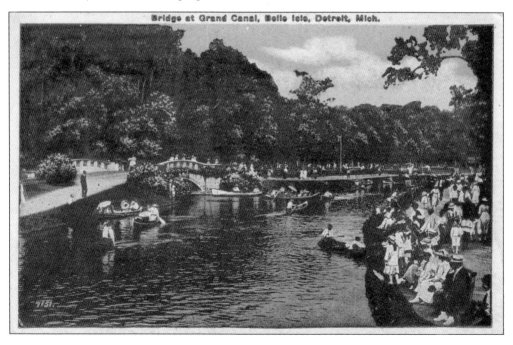

Bridge at Grand Canal, Belle Isle, Detroit, Mich.

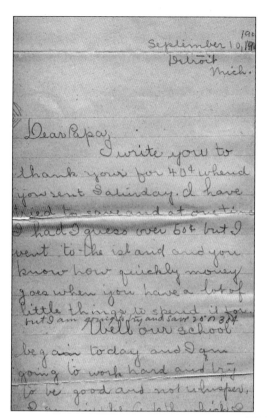

"DEAR PAPA," SEPTEMBER 10, 1900.

Young Detroiter Janet Wendell Gibbons wrote this letter to her father in New York City: "Dear Papa, I write you to thank you for 40¢ [which] you sent Saturday. I have tried to save and at one time I had I guess over 50¢ but I went to the island and you know how quickly money goes when you have a lot of little things to spend it for but I am going to try and save 20 or 30¢. Well out school begain [sic] today and I am going to work hard and try to be good and not whisper."

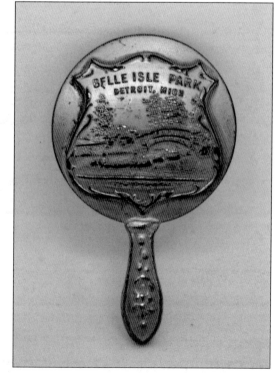

BELLE ISLE POCKET MIRROR. This gold-plated pocket mirror, two and one half inches in length, is an example of the many "little things" from which Janet would have chosen an island souvenir. The convex shape of the mirror allows the viewer to see her entire face, and the back of the mirror is embossed with flowers and a badge-shaped view of canoeists paddling under one of Belle Isle's bridges.

JANET WENDELL GIBBONS (1887–1970). Janet Wendell Gibbons, writer of the letter on the previous page, was born in Detroit, Michigan, on January 27, 1887. She attended Detroit's Central High School and later married Percival Grant MacArthur and raised her five children in Grosse Pointe. This photograph of young Janet was taken at around the same time as she wrote the letter to her father.

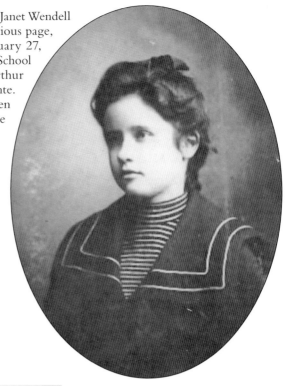

ROBERT TILDEN GIBBONS (1859–1924). Robert Tilden Gibbons, recipient of his daughter's letter, was born on October 27, 1859, in Rutland, Vermont. He spent his childhood in Nagasaki, Japan, and then Boston, Massachusetts, where, while attending university at the Massachusetts Institute of Technology, he met his future wife, Detroit native Ella Wendell. Robert was a banker in Detroit and at other banks around the country.

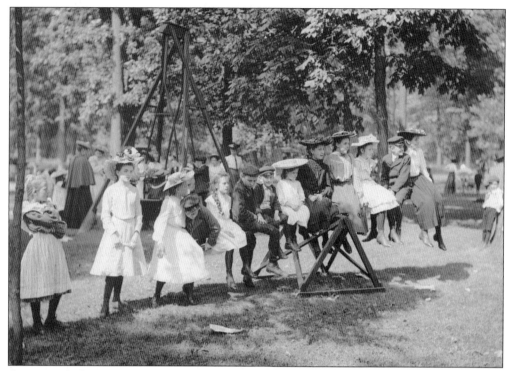

CHILDREN'S PLAYGROUNDS. In 1901, commissioner of the Department of Parks and Boulevards Robert E. Bolger first petitioned for the installation of children's playgrounds around Detroit and specifically on Belle Isle. The idea of children's playgrounds, as they are known today, was relatively new for cities at that time. Places such as New York, Philadelphia, and Boston had already built playgrounds and had reported many benefits in giving children a place of activity after school and on vacations, which in turn kept them from playing in the streets. The postcard above shows children piled onto the playground teeter-totter (or seesaw) in 1904. The postcard below shows children enjoying the bridges and slides of the play structure around 1921.

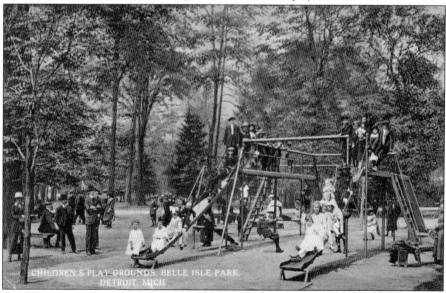

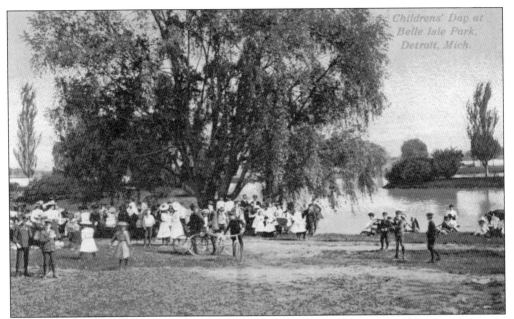

CHILDREN'S DAY AT BELLE ISLE. The very first Children's Day at Belle Isle was held on May 26, 1900. It was reported that over 100,000 people attended the celebration that provided events throughout the day and ended with a concert in the evening. The event was so well received that Mayor William C. Maybury suggested the day be celebrated annually and that it become a legal holiday.

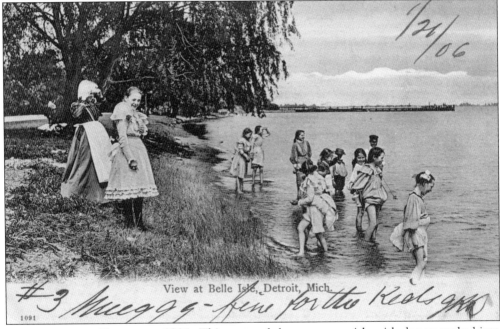

WADING IN THE RIVER, C. 1906. This postcard shows young girls with dresses tucked into their pantaloons and boys in short pants wading to their knees in the Detroit River on the Detroit side of Belle Isle. The smiles and laughter on the faces of the children and their chaperone seem to prove how much fun it was when they were allowed to "let loose" and play in the water.

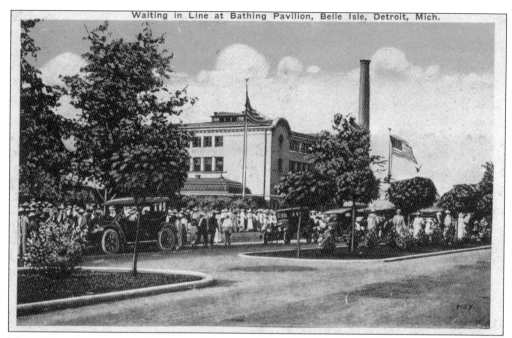

Waiting in Line at Bathing Pavilion, Belle Isle, Detroit, Mich.

WAITING IN LINE AT THE BATHING PAVILION. The Belle Isle bathing beach provided a respite on hot summer days for children and adults alike. According to the 1908 annual report, the prior season saw 74,547 bathers and plans were being made to build a new bathhouse for the upcoming season. A total of $70,000 was appropriated for construction on the north shore of Belle Isle with a bathing beach about 1,500 feet long.

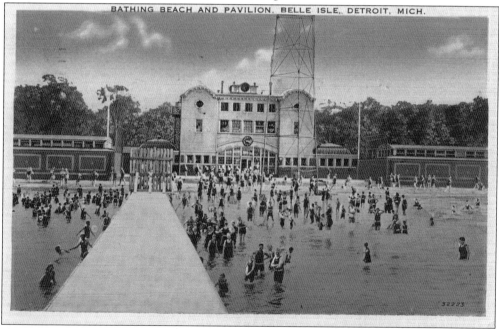

BATHING BEACH AND PAVILION, BELLE ISLE, DETROIT, MICH.

BATHING BEACH AND PAVILION. Completed in 1909 at a cost of $100,000, the bathing beach and pavilion was considered to be "without a doubt the finest place of its kind in the country," as stated in the book *Detroit: America's Most Beautiful City.*

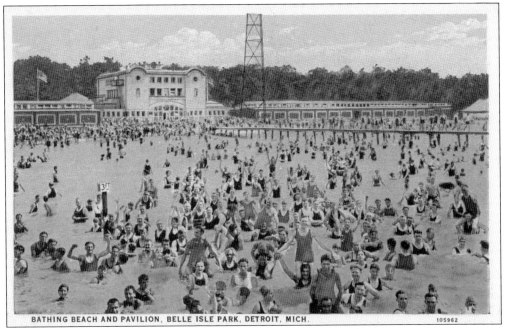

BATHING BEACH AND PAVILION, BELLE ISLE PARK, DETROIT, MICH. 105962

SUMMER IN THE CITY. A 1916 *Northwestern Reporter* (vol. 157) reports that the bathing pavilion and bathing beach at Belle Isle entertained nearly a quarter of a million visitors during the 1915 season. It also emphasizes that the city employed a large number of lifeguards to look out for the safety of its guests enjoying a day at the beach.

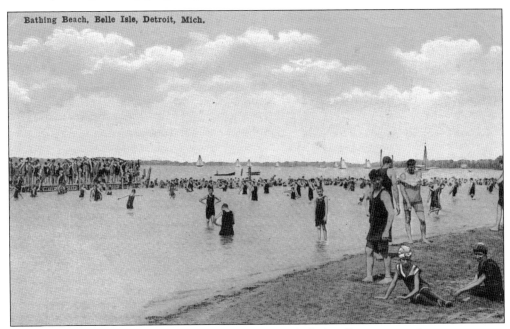

Bathing Beach, Belle Isle, Detroit, Mich.

A DAY AT THE BEACH. According to a 1916 *Detroiter* (vol. 7), efforts were under way to secure permission from federal authorities in Washington for the use of river shore in front of Fort Wayne for public bathing purposes. Due to the overcrowding of the Belle Isle bathing beach, it was noted that hundreds of people stood in line for hours in order to get into the water.

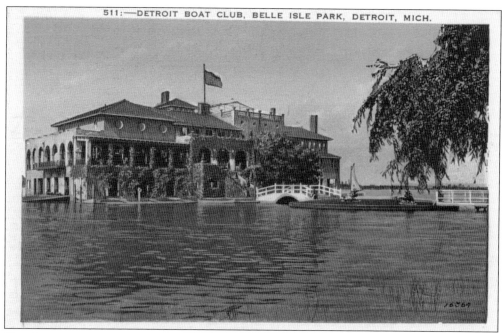

511:—DETROIT BOAT CLUB, BELLE ISLE PARK, DETROIT, MICH.

THE BEGINNING OF THE DETROIT BOAT CLUB. The Detroit Boat Club was established in 1839 and is the oldest boat club in the United States. The early years saw the club move locations in order to accommodate additional boats as membership grew. Its last boathouse in Detroit was located at the foot of Joseph Campau Street. When the lease ran out in 1889, the Detroit Boat Club moved to Belle Isle.

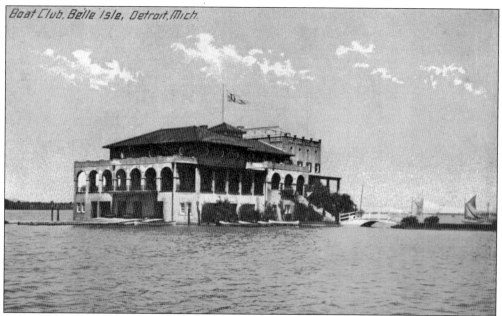

Boat Club, Belle Isle, Detroit, Mich.

DETROIT BOAT CLUB ON BELLE ISLE. The first boathouse built on Belle Isle was constructed in 1891 and burned down in 1893. A second boathouse was destroyed by fire in 1901. The current boathouse was dedicated in 1902 and was one of the first concrete structures built in the United States.

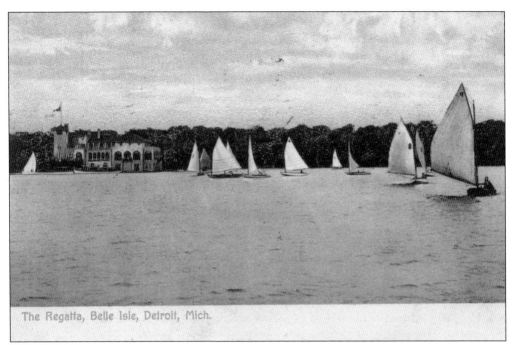

The Regatta, Belle Isle, Detroit, Mich.

OUT ON THE WATER WITH THE DETROIT BOAT CLUB, C. 1907. Originally founded as a rowing club, the Detroit Boat Club has flown its blue-and-white colors at every national rowing regatta since 1873. In 1907, the yachtsmen desired to purchase a 21-foot racing yacht from Cameron Currie in order to represent the club in the 21-foot sailing class. They offered Currie $700 for his yacht *Otsiketa*, but he refused to sell her. In 1956, seven Detroit Boat Club members competed on the US Olympic team and brought home two silver medals. With a long and rich history of competitive racing, the Detroit Boat Club continues its time-honored traditions and sportsmanship.

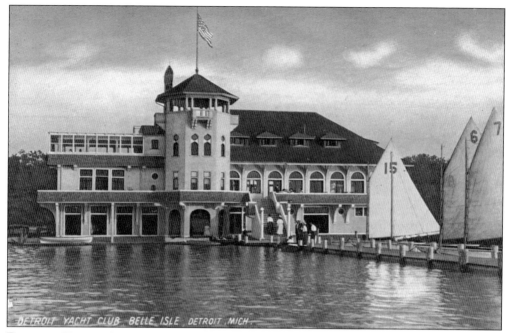

DETROIT YACHT CLUB, 1905. The founding of the Detroit Yacht Club dates to 1868, with its first clubhouse opening at the foot of McDougall Street, south of Jefferson Avenue, in the late 1870s. During the early 1880s, there was dissension within the club, causing part of the membership to split away and found the Michigan Yacht Club. The Detroit Yacht Club was revitalized in 1884 and opened its first clubhouse on Belle Isle in 1891 at the cost of $10,000. It was destroyed by fire in 1904, and this 1905 incarnation of the clubhouse was built immediately upon the ashes at that same site for $20,000. The club was considered one of the largest on the Great Lakes and prominently featured sailing by maintaining a fleet of 20 one-design catboats in which members sailed weekly regattas.

570:—ONE OF THE BEAUTY SPOTS, BELLE ISLE, DETROIT, MICH.

46

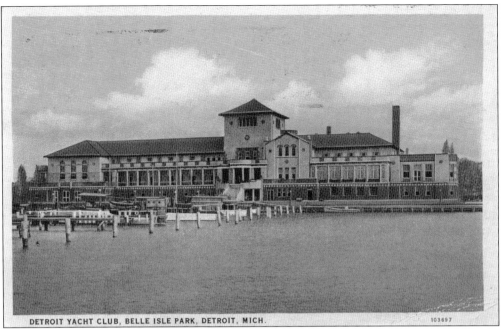

DETROIT YACHT CLUB, BELLE ISLE PARK, DETROIT, MICH. 103697

DETROIT YACHT CLUB, 1923 TO THE PRESENT. Yacht club commodore Garfield "Gar" Wood brought world-class attention to the yacht club as the first man to travel over 100 miles per hour on water. He was the world water speed record holder several times over and had multiple Gold Cup victories and Harmsworth Trophies. The club's membership soared in the early 1920s, causing it to outgrow the 1905 structure. The yacht club commissioned architect George Mason, who also built the famed Grand Hotel on Mackinac Island, to build the $1 million Mediterranean-style villa clubhouse, which opened in 1923 with a dedication by Commodore Wood. The club proudly survived the Great Depression and its 93,000-square-foot clubhouse remains the largest yacht club clubhouse in the United States. In 2011, the Detroit Yacht Club was listed in the National Register of Historic Places.

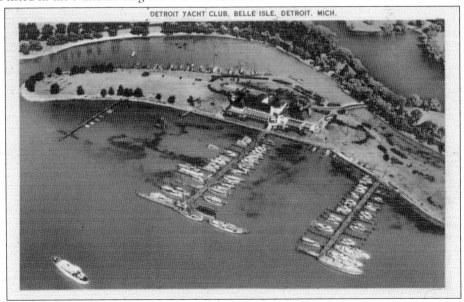

DETROIT YACHT CLUB, BELLE ISLE, DETROIT, MICH.

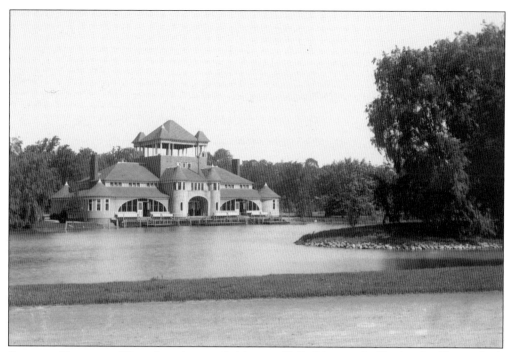

SKATING PAVILION. The winter home of visitors to Belle Isle was the Skating Pavilion, which opened to ice-skaters on January 1, 1893. The skating pavilion was situated on the edge of South Lake (now Lake Tacoma), which had opened to skaters two years prior. Skating on the lake had become such a popular attraction, and the main hub of activity in the winter months, that the parks commission decided to build a facility that would provide a place for warmth and refreshment during a day of winter skating. During the summer, it was used as a shelter pavilion and provided refreshment and shade from the summer sun. The old skating pavilion was replaced by the Flynn Memorial Skating Pavilion in 1950.

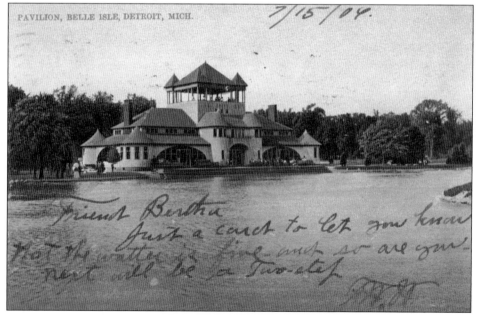

PAVILION, BELLE ISLE, DETROIT, MICH.

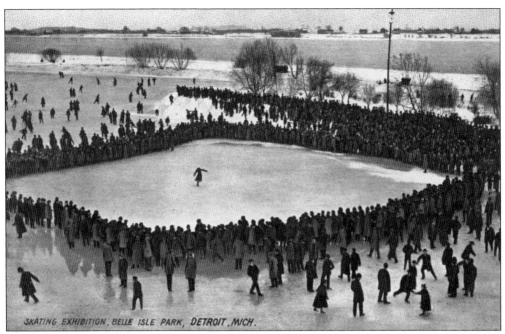

SKATING EXHIBITION, BELLE ISLE PARK, DETROIT, MICH.

SEASONAL VIEWS FROM THE SKATING PAVILION. These winter and summer scenes offer a view looking out over South Lake, or Lake Tacoma, from the Skating Pavilion. Skating competitions and exhibitions, as well as ice hockey games, were among the most popular attractions on the isle. The postcard above features a single skater performing an exhibition for a large crowd of onlookers who formed a ring around her, while other skaters took part in their own performances elsewhere around the lake. The summer view features canoeists paddling around the lake, while a steamer goes by on the Detroit River in the background. River Drive (now the Strand) formed the barrier between the lake and river.

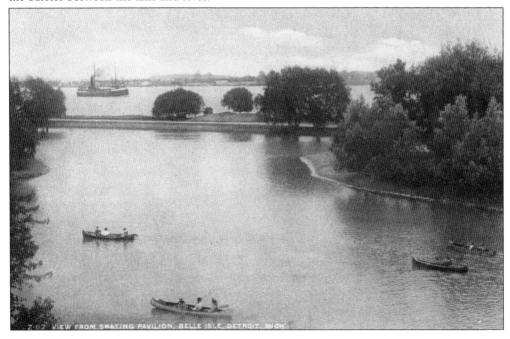

Z-62 VIEW FROM SKATING PAVILION, BELLE ISLE, DETROIT, MICH.

MOTORING. As automobile manufacturing in the Motor City continued to grow, the desire to own one increased. The boom of the automobile industry provided an opportunity for the average family to own a personal vehicle, and America was now rolling over miles of roadway on a regular basis. Belle Isle was no exception and provided miles of scenic routes for people to enjoy.

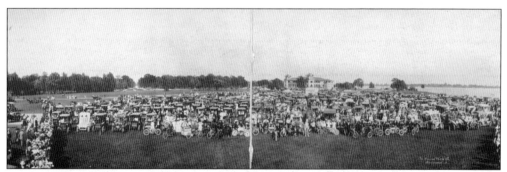

GLIDDEN AUTO TOUR, BELLE ISLE, C. 1909. The Glidden Auto Tour began as a way for the newly formed American Automobile Association (AAA) to encourage the acceptance of the automobile, promote the need for better roads, and formulate proper rules for governing the use of the automobile. The Glidden Auto Tour existed from 1904 to 1913. (Library of Congress.)

BOAT RENTALS. This image taken sometime between 1890 and 1920 shows one of the wooden boat sheds on Belle Isle filled with rowboats and sailboats ready to be rented. A woman and child sit in a boat prepared to go out on the canal, while another woman sits on the dock with a gentleman standing beside her. (University of Michigan Bentley Historical Library.)

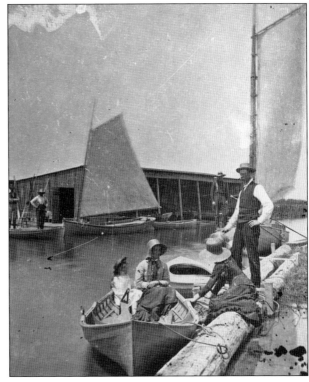

COMMERCIAL FISHERY. Barnabas Campau is believed to have established the first commercial fishery on Belle Isle while in ownership of the island. The fishery continued to operate even after Belle Isle was purchased by the City of Detroit. At the height of the fishing industry, earnings grew to approximately $30,000 annually. (University of Michigan Bentley Historical Library.)

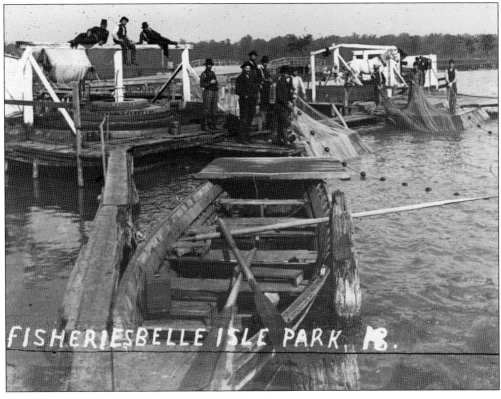

RECREATIONAL FISHING. Fishing has long been a favorite pastime for visitors to Belle Isle. Fishing clubs were formed, such as the Belle Isle Fly and Bait Casting Club, and fishing derbies, rodeos, and tournaments were held for both children and adults and the novice or professional fishermen alike. (University of Michigan Bentley Historical Library.)

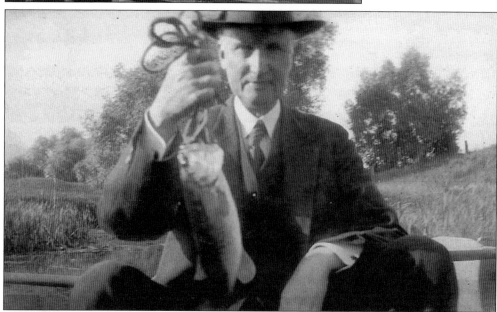

FANCY FISHERMAN. Whether in a boat or from the shore, a fishing pole, a sunny day, and friendly companion could provide hours of entertainment. Anglers could cast for a large variety of fish, including walleye, yellow perch, largemouth bass, smallmouth bass, rock bass, crappie, bluegill, lake sturgeon, and northern pike to name a few.

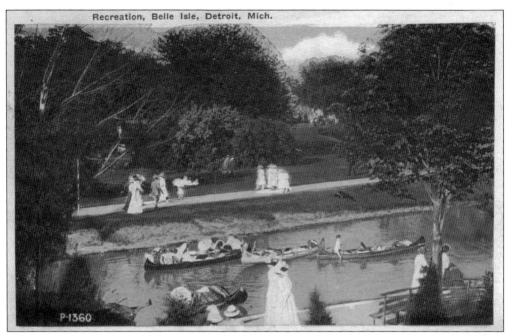

P-1360

RECREATIONAL ACTIVITIES, C. 1911. While canoeing through the waterways and strolling along meandering paths have always been popular, bicycling has also been a popular attraction on Belle Isle since the late 1890s due to the miles of paths and roadways for cyclists to traverse during a day on the island. The Department of Parks and Boulevards reported on July 1, 1897, "The letting of bicycles has come to be one of the paying privileges leased by the Commission, and to accommodate bicycle riders many extra seats were placed on the upper end of Belle Isle and a few along the Boulevard. If the popularity of the wheel continues, a shelter or pavilion and checkroom are contemplated for the convenience of the riders." The island today still features six-miles of designated bike lanes for cyclists to use and enjoy.

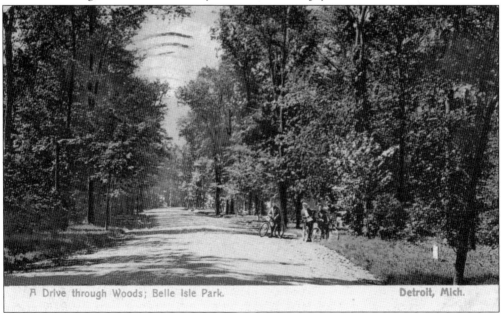

A Drive through Woods; Belle Isle Park. Detroit, Mich.

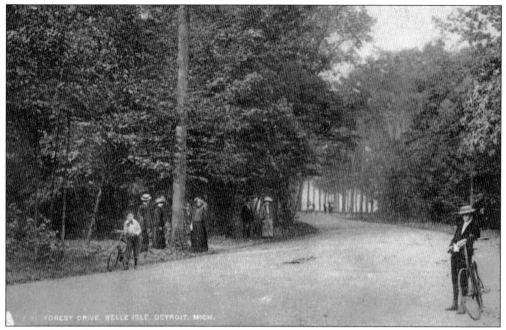

FOREST DRIVE, BELLE ISLE, DETROIT, MICH.

CYCLING DOWN FOREST DRIVE, c. 1913. The scene of cyclists and pedestrians along the isle's tree-lined Forest Drive was chosen for Selma Johnson of Cuyahoga Falls, Ohio, by her friend Jack, who recently settled on High Street in Detroit. Jack states, "This picture on the other side is a place that would appeal to you. It is certainly grand to roam thru that part of the Isle. Try it sometime." The reader could assume that Selma was a lover of the outdoors, because Jack goes on to suppose that she would be likely be out riding for the afternoon when his postcard arrived to her in Ohio.

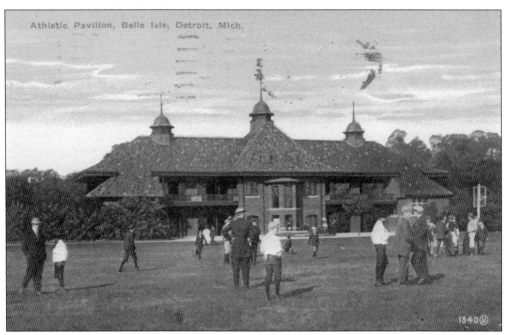

BICYCLE AND ATHLETIC PAVILION. The popularity of bicycling allowed the League of American Wheelman (LAW), Michigan Division to secure $10,000 from the City of Detroit to build a bicycle pavilion on Belle Isle in 1898. The two-story building was designed by architect Edward A. Schilling and opened August 4, 1899. The main floor was designed to store up to 500 bicycles, while the upper floor served as an open-air gallery. Another $2,500 was secured in 1899 for additional upgrades that would provide for bicycle maintenance. The city leased part of the pavilion to be used as a bicycle rental concession. It is one of the oldest surviving buildings on Belle Isle.

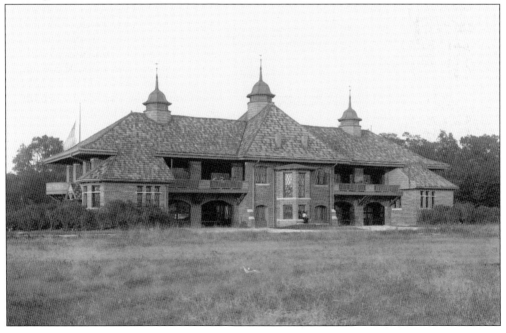

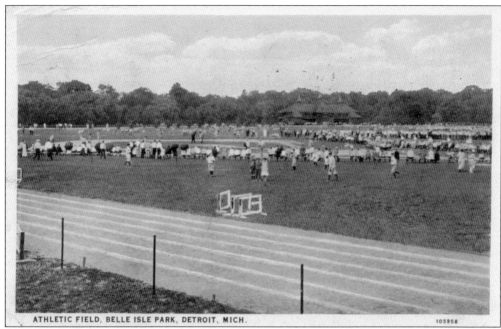

ATHLETIC FIELD, BELLE ISLE PARK, DETROIT, MICH. 105958

ATHLETIC FIELD. In 1904, bridge No. 13 was built over the Nashua Canal leading to the athletic field. When finished, the athletic field would contain 30 acres of recreational space. The upper portion of the athletic field was subdivided into spaces for tennis courts, basketball, and croquet. Several baseball diamonds, a track-and-field event area, a football field, and soccer field were added as well. A golf course rounded out the athletic venues available on the island. Pictured above is the track-and-field area with the Athletic Pavilion seen in the background. Seen below are players taking advantage of the ball grounds for a baseball game. (Below, Library of Congress.)

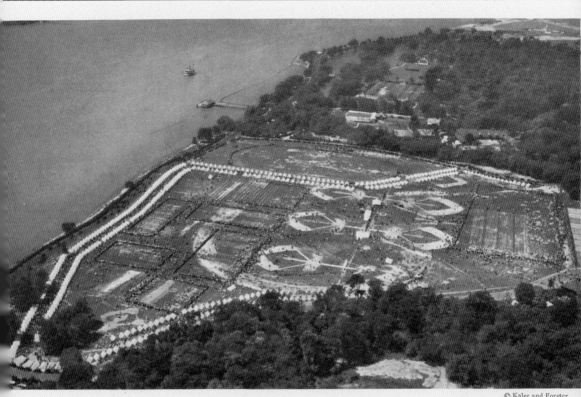

MICHIGAN TAKES HER ATHLETICS WHOLESALE

© Kalec and Forster

DETROIT PUBLIC SCHOOLS ANNUAL MEET. This aerial view of the athletic field shows it set up for use during one of the Detroit Public Schools' Belle Isle meets. This annual event was founded by Loren M. Post, who became director of health education of Detroit's public schools. Post's vision for the event was to teach boys and girls necessary attributes, such as sportsmanship, that would benefit them as they grew into adulthood. The Belle Isle meets began in 1914 with only a few dozen participants and grew to over 28,000 registered entrants by the 15th annual meet in 1929. The event hosted a variety of athletic competitions designed for students of Detroit and metropolitan–area elementary and high schools to compete against one another for athletic glory. The top right corner of this image shows the James Scott Memorial Fountain in the distance and the dome of the Anna Scripps Whitcomb Conservatory and the Belle Isle Aquarium just above the athletic field.

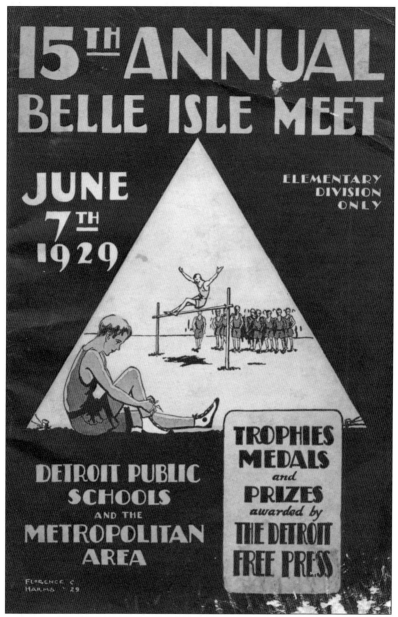

THE 15TH ANNUAL BELLE ISLE MEET, JUNE 7, 1929. The Detroit Public Schools and the Metropolitan Area 15th Annual Belle Isle Meet was arranged and operated by the Department of Health Education of the Detroit Public Schools and sponsored and financed by the *Detroit Free Press*. The cover for the 15th annual Belle Isle meet program was created by Florence C. Harms, art teacher at the McMillan School. When asked by the *Detroit Free Press,* June 5, 1929, about her cover design she said, "Although the field of athletics seems to be far from the field of art I have tried to educate my pupils to correlate their art with any worthy cause. . . . I tried, when I submitted the cover design for the program, to give my pupils an example of what I had been teaching them in this respect. It seems to me that art serves a better purpose if it can be applied usefully. I can think of no more useful way of applying it than to help in sponsoring some such event at the Belle Isle Field Meet."

Fifteenth Annual Field Meet

DETROIT PUBLIC SCHOOLS

and

THE METROPOLITAN AREA

BELLE ISLE, JUNE 7th, 1929

Arranged and Operated by the Department of Health Education
of the Detroit Public Schools

Sponsored and Financed by The Detroit Free Press

HONORARY OFFICIALS

HON. FRED W. GREEN, Governor of Michigan.
HON. JOHN C. LODGE, Mayor of Detroit.
MRS. LAURA OSBORN, President of the Board of Education.
HON. HENRY W. BUSCH, Commissioner of Parks and Boulevards
COMMISSIONER WILLIAM P. RUTLEDGE, Police Department.
DR. HENRY VAUGHN, Commissioner of Health.
HON. C. E. BREWER, Commissioner of Recreation.
DR. I. M. ALLEN, Superintendent of Schools, Highland Park.
MR. M. R. KEYWORTH, Superintendent of Schools, Hamtramck.
MR. A. McDONALD, Superintendent of Schools, River Rouge.
MR. A. A. RIDDERING, Superintendent of Schools, Melvindale.
MR. C. J. MILLER, Superintendent of Schools, Ecorse.
MRS. LOA S. LINDSEY, Superintendent of Schools, South Lake.
MR. M. B. RAUCH, Superintendent of Schools, Sibley.
MR. FRED SANBORN, Superintendent of Schools, East Detroit.

MR. GUY BATES.	MISS RACHEL MCKINNEY.
MR. HERMAN BROWE.	MR. GEORGE BIRKAM.
MR. ROY STEVENS.	MR. JOHN THOMAS.
MR. JAMES BAIRD.	MR. JAMES H. VOORHEES.
MR. EARL LAING.	MISS JENNIE FLEMING.
MISS FLORENCE GEER.	MISS NORA L. EGAN.
MISS FRANCES HARDIE.	MISS INEZ CASWELL.

MISS EMMETT WEATHERBY

ACTIVE OFFICIALS

MR. FRANK CODY, President of the Day
T. F. WEST, Director of the Meet
BEATRICE B. MOSLEY, in Charge of Girl's Events
E. R. HATTON, Business Manager
DONALD P. KOTTS, ALBERT F. KOEPCKE, Publicity
INSPECTOR LOUIS L. BERG, Marshal

Substitutes, Information, Tents—MARION MAYER
Assistants—MARTHA ROSS, MILDRED CHAPP
Property—JEAN HITCHCOCK
Assistants—JEWELL DURKIN, HILDEGARDE MAYER

BOYS' EVENTS

100-YARD DASH

In Charge—Arthur Erwin.
Chief Clerk—Walter Draper.

SENIOR COURSE

Starter—Joseph Cooney.
Assistant—Paul Vollmar.
Clerk—Leo Randall.
Assistant—Louis C. Thiele.
Timer—Ted Blakeley.

Judges—Ervin Johnson, C. Poggemiller, J. R. Paisley, O. R. Atkins, F. R. Menold, Earl Mayrend.

JUNIOR COURSE

Starter—William Donnelly.
Assistant—Shelby Harrington.
Clerk—Harry Gragg.
Assistant—C. C. Barnes.
Timer—John Aliber.
Judges—Oscar Fosmoe, George Knapp, L. J. Smith, Alphonse Ederer, Gerald Baysinger, Wilbur Chapman.

4

THE 15TH ANNUAL MEET ORGANIZERS. The 115-page souvenir programs for the field meet were distributed to all the participating schools two days prior to the meet. The programs contained a schedule of events, the names of all 28,000 entrants into meet events, and a list of trophies and prizes that were to be given to all the successful contestants; those prizes were provided by the *Detroit Free Press.* Organizers even devised a plan to keep Belle Isle clean after use by the estimated 300,000 attendees of the event by announcing that each school could win prizes for maintaining cleanliness and neatness around its tent grounds. Two inspections would take place on the day of the event, and schools that complied earned citizenship emblems to be displayed with pride on their tents and then carried back to their respective schools as badges of honor.

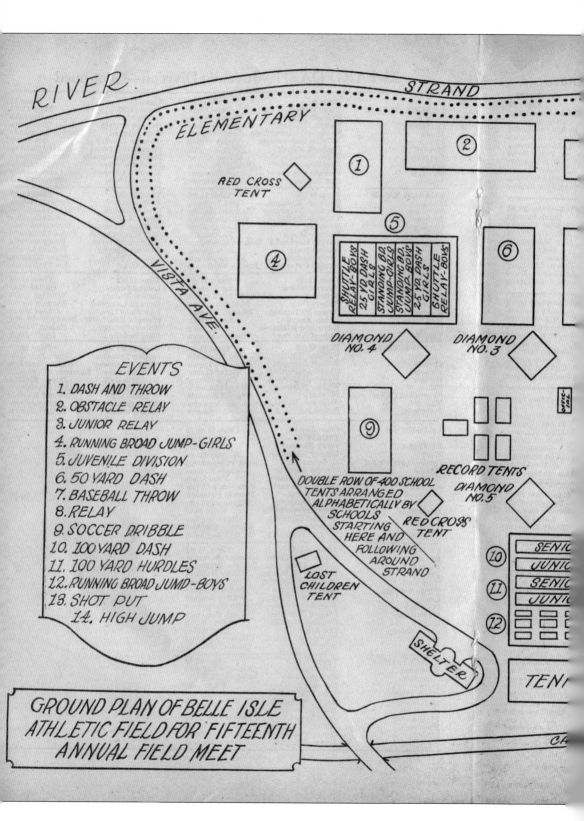

RIVER.

STRAND

ELEMENTARY

RED CROSS TENT

① ② ④ ⑤ ⑥

VISTA AVE.

SHUTTLE RELAY-BOYS
25 YD DASH GIRLS
STANDING BD. JUMP-GIRLS
STANDING BD. JUMP-BOYS
25 YD DASH GIRLS
SHUTTLE RELAY-BOYS

DIAMOND NO. 4
DIAMOND NO. 3

OFFICIAL

EVENTS

1. DASH AND THROW
2. OBSTACLE RELAY
3. JUNIOR RELAY
4. RUNNING BROAD JUMP-GIRLS
5. JUVENILE DIVISION
6. 50 YARD DASH
7. BASEBALL THROW
8. RELAY
9. SOCCER DRIBBLE
10. 100 YARD DASH
11. 100 YARD HURDLES
12. RUNNING BROAD JUMD-BOYS
13. SHOT PUT
 14. HIGH JUMP

⑨

RECORD TENTS
DIAMOND NO. 5

DOUBLE ROW OF 400 SCHOOL TENTS ARRANGED ALPHABETICALLY BY SCHOOLS STARTING HERE AND FOLLOWING AROUND STRAND

RED CROSS TENT

LOST CHILDREN TENT

⑩ SENIO
 JUNIO
⑪ SENIO
 JUNIO
⑫

SHELTER

TEN

CA

GROUND PLAN OF BELLE ISLE ATHLETIC FIELD FOR FIFTEENTH ANNUAL FIELD MEET

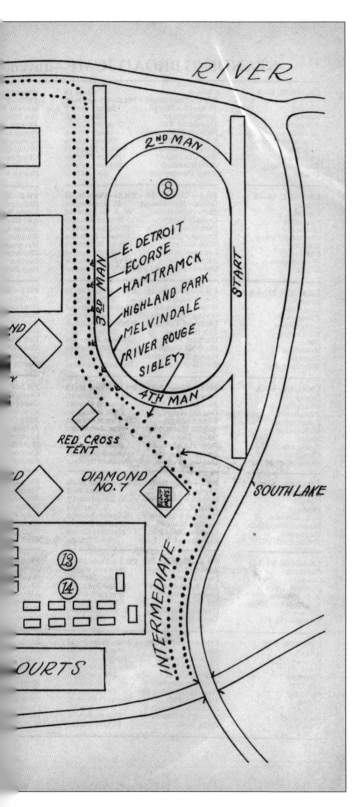

RIVER

2ND MAN

⑧

E. DETROIT
ECORSE
HAMTRAMCK
HIGHLAND PARK
MELVINDALE
RIVER ROUGE
SIBLEY

3RD MAN

START

4TH MAN

RED CROSS
TENT

DIAMOND
NO. 7

SOUTH LAKE

⑬
⑭

INTERMEDIATE

OURTS

ATHLETIC FIELD RENDERING, JUNE 7, 1929. This hand-drawn map of the athletic field and Belle Isle field meet grounds shows a detailed view of events for participants and attendees of the 15th annual meet. Perhaps most notably, there was a double row of 400 white canvas tents arranged alphabetically by school set out to surround three sides of the athletic field. Readers will also notice the modern names, as they are still known today: the Strand and Vista Avenue. Loiter Way would appear just off the bottom edge of the map. The athletic fields are still intact on Belle Isle today.

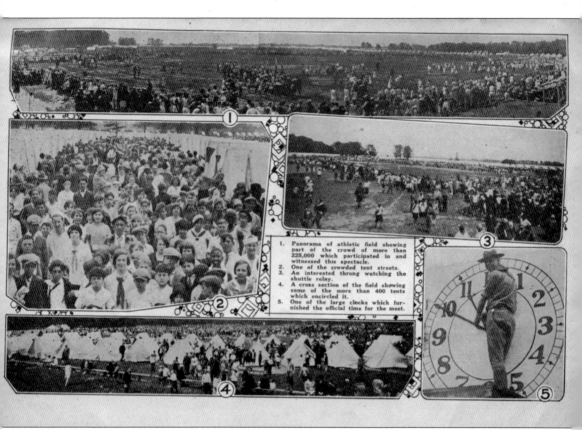

1. Panorama of athletic field showing part of the crowd of more than 225,000 which participated in and witnessed this spectacle.
2. One of the crowded tent streets.
3. An interested throng watching the shuttle relay.
4. A cross section of the field showing some of the more than 400 tents which encircled it.
5. One of the large clocks which furnished the official time for the meet.

THE 14TH ANNUAL BELLE ISLE MEET, JUNE 1928. This collage of photographs is from the 14th annual Belle Isle field meet in 1928. There were approximately 225,000 people in attendance for that meet, and these images show the vast scope of the event, including the overcrowded double tent row and the large crowd of spectators at individual events. Although it is unclear how many annual meets there were, mentions of the event seem to have declined after 1933. The Detroit Public Schools did not hold a meet that year due to the early closing of the schools. A few other mentions through the early 1930s discuss athletic events using a plan based on that of the annual meet, but an event as large as the one that was seen in 1929 did not appear in the newspapers again.

Three

ISLAND PARK GEMS

Many of Belle Isle's unique gems have survived through the years and stand as a testament to the dreams and visions of the people who were dedicated to creating a beautiful park for the city of Detroit. This chapter explores some of the gems that have graced the island and the people who made them happen. The rich history of the island makes for some fascinating tales that are forever noted—but often hidden—in newspapers, books, and photographs. This chapter seeks to uncover some of those hidden gems and bring them back into view for today's reader. Embracing the past can give a renewed vision for the future.

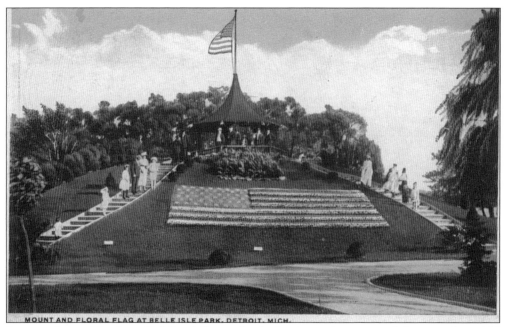

MOUNT AND FLORAL FLAG AT BELLE ISLE PARK, DETROIT, MICH.

FLORAL FLAG. The beautiful floral flag at the Cedar Mound was one of the many beautiful landscaped attractions on Belle Isle. A patriotic display of festive flowers symbolized the pride Detroiters had for their country. Detroit was a melting pot of ethnicities representing people from around the globe, most looking to better their fortunes and futures in a thriving and growing city.

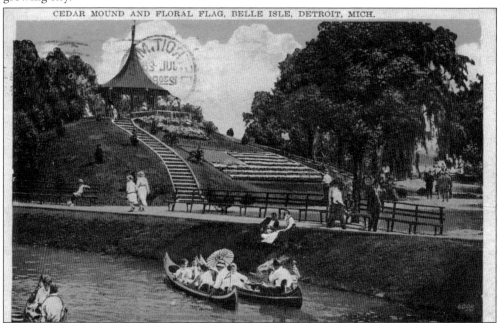

CEDAR MOUND AND FLORAL FLAG, BELLE ISLE, DETROIT, MICH.

CEDAR MOUND. The Belle Isle Cedar Mound (also known as Cedar Mount or Cedar Hill) was created from earth that was excavated during the digging or deepening of the various canals and lakes. A popular attraction for all guests, it featured a waterfall, a tunnel, large floral displays, and a pavilion at the top.

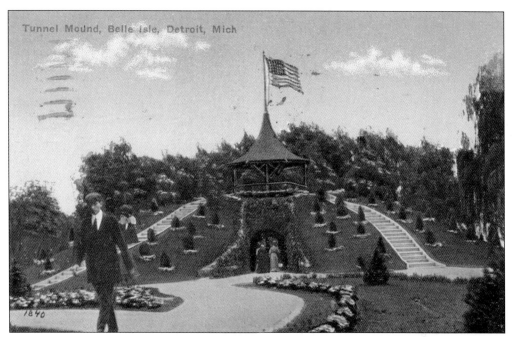

CEDAR MOUND TUNNEL, C. 1914. A unique feature of the Cedar Mound was the rock-walled tunnel that ran through the middle of the mound. The tunnel provided guests with a shaded walkway that connected various paths to the casino, Lake Takoma (now Lake Tacoma), and various floral gardens.

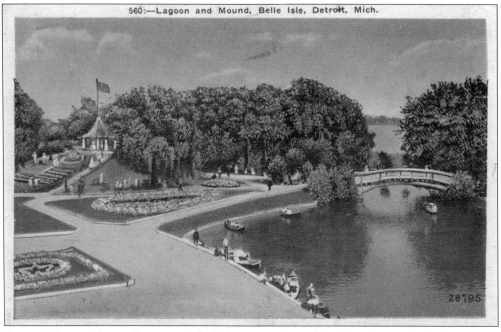

CEDAR MOUND, LAKE TAKOMA. Lake Takoma was formed in 1887, along with the first casino. The Belle Isle Cedar Mound was located on Lake Takoma and erected from earth excavated from the digging of the canals. It was a popular spot whether on land or canoeing the canals, and the magnificent landscaping and cascading waterfall made for an enjoyable day in the park.

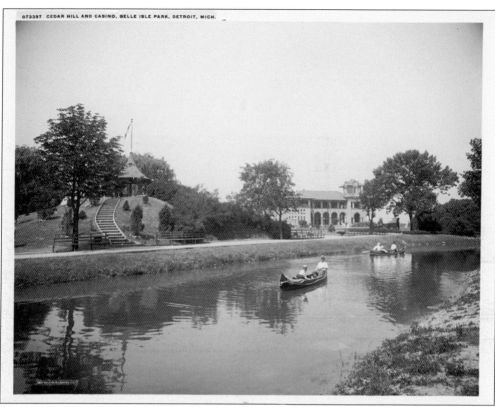

073397 CEDAR HILL AND CASINO, BELLE ISLE PARK, DETROIT, MICH.

CEDAR MOUND AND CASINO. Opening in 1887, the first casino on Belle Isle was designed by the Detroit firm of Mason and Rice. With its proximity to the entry points of the island, this section of Belle Isle became an immediate success as people enjoyed socializing at the casino, strolling along the various pathways, or canoeing the waterways. An interesting article appears in the *Detroit Free Press* dated June 29, 1894, regarding the installation of a new telephone at the casino. The telephone company would not permit the public use of the telephone without a charge of 10¢ per message. This was in addition to the $100 yearly fee required from the casino. Commissioner Charles K. Latham, thinking the charges excessive, recommended that the board ask that patrons be allowed telephone privileges.

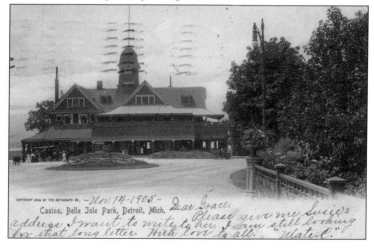

Casino, Belle Isle Park, Detroit, Mich.

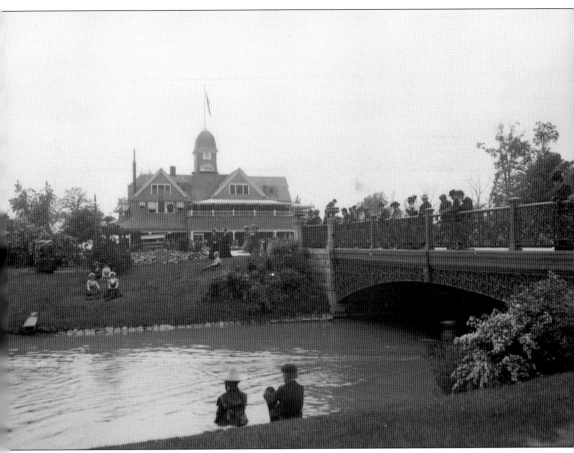

OUTGROWING THE "OLD" CASINO. By 1900, it was apparent that the casino was too small to accommodate the needs of its guests. Park commissioner Robert E. Bolger was determined to see a modern, fireproof casino replace the inadequate wooden structure that had been built in 1887. In 1903, a committee was appointed by the Michigan chapter of the American Institute of Architects to submit a drawing for a new casino. Mason & Reed-Hill, architects, submitted a drawing and according to the plans the cost would be approximately $175,000. Nothing was spared in the design that would feature a grand hall, waiting rooms, dining facilities, galleries, a gentleman's smoking room, and coffee rooms to name just a few of the featured amenities that were planned. Commissioner Bolger was unable to secure the appropriations necessary and the new casino was not built until 1907. (Library of Congress.)

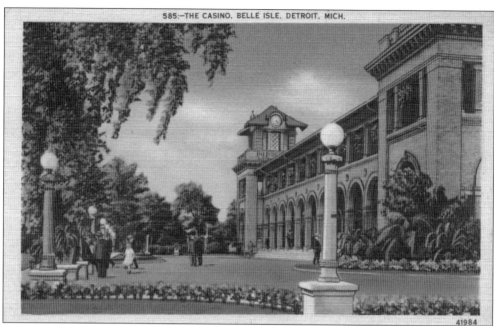

41984

"NEW" BELLE ISLE CASINO. Often mistaken as having been designed by Albert Kahn, the Beaux-Arts–style casino, featuring open arcades and square towers, was actually designed by Van Leyen & Schilling, a Detroit architectural and engineering firm, and was completed in 1907. Edward Christopher Van Leyen and Edward Arthur Schilling formed a partnership in the early 1900s and were later joined by H.J. Keough and Robert Reynolds. The firm is credited with designing many notable churches—Nativity of Our Lord, Holy Family Roman Catholic Church, and St. Theresa of Avila Catholic Church—as well as over 200 schools, including St. Charles Borromeo School, throughout Michigan, Ohio, and Ontario, Canada.

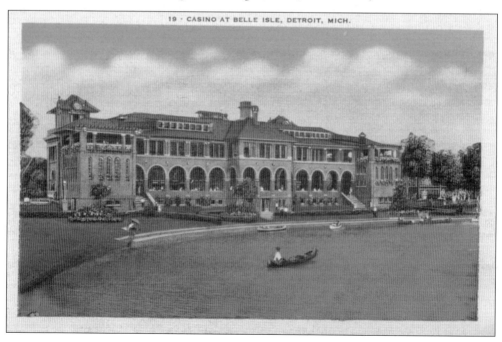

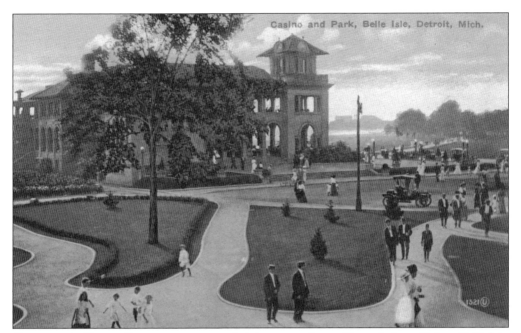

CASINO AND PARK. Controversy surrounded the new casino as Commissioner Robert E. Bolger was ousted from office before the project was completed. With three sets of plans drawn, the third plan was chosen and completed in 1907. Problems ensued when the new commissioner refused to pay $6,000 to the Van Leyen & Schilling architectural firm for the second set of plans.

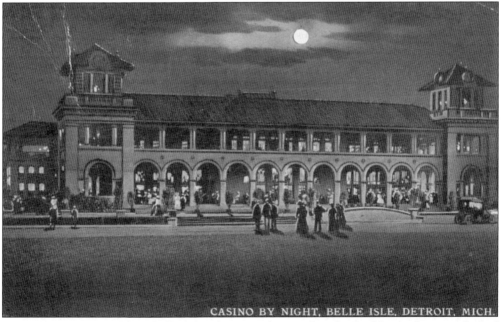

CASINO BY NIGHT. Although the casino has never been a place for gambling, it has never lacked for entertainment. Daytime activities revolved around luncheons, society meetings, and small get-togethers. Nighttime events included dinner parties and dancing. The long sweeping views of the lake from the veranda invited one to sit and unwind from a busy day.

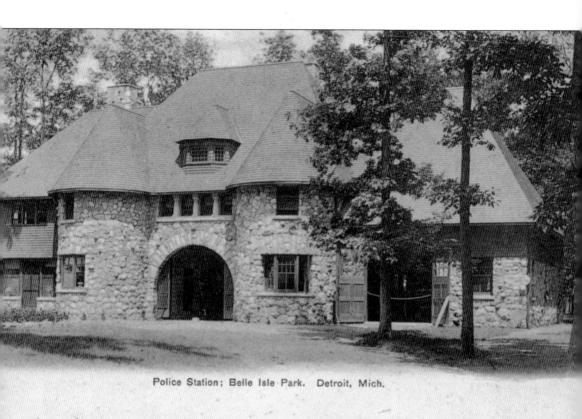

Police Station; Belle Isle Park. Detroit, Mich.

POLICE STATION. Built in 1893, the police headquarters looked nothing like a typical police station or jail. Designed by architects George Mason and Zacharias Rice, it was created in the style of a fieldstone farmhouse and built to complement the natural landscape. Comfortably furnished and beautifully decorated, it was used more as a detention facility. Aside from being the police station, it also served as a makeshift holding facility. The matron's headquarters adjoined the station, and she would often serve as a nurse to those in need of medical attention while on the island. Heat exhaustion, swimming accidents, and boating accidents were regular occurrences in the summer, while winter brought numerous skating and sledding mishaps.

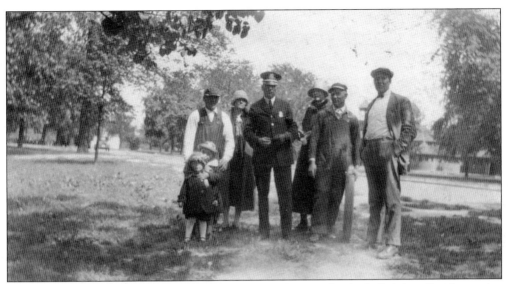

BELLE ISLE POLICE OFFICER AND GUESTS. The early years for the Belle Isle police force were relatively peaceful, with its main focus being a friendly presence and safeguarding the isle and looking out for people in distress. The automobile and Prohibition brought new challenges for the police department as Belle Isle was a favorite go-between for bootlegging alcohol between Canada and the United States. A sharper focus was now on criminal activities.

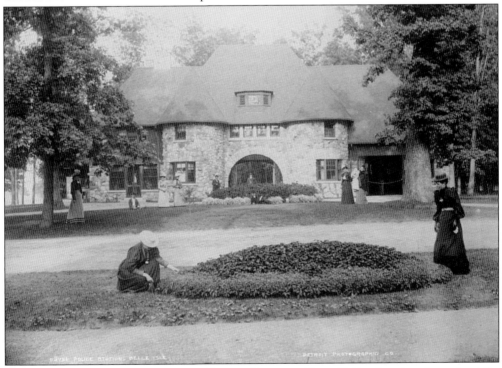

TENDING THE FLOWERBEDS AT THE POLICE STATION. Beautiful landscaping throughout the isle needed constant maintenance. These ladies are tending the flowerbed in front of the police station as an act of civic pride and duty. Flowers grown at the Belle Isle Horticultural Building were planted yearly throughout the city's park system. (Library of Congress.)

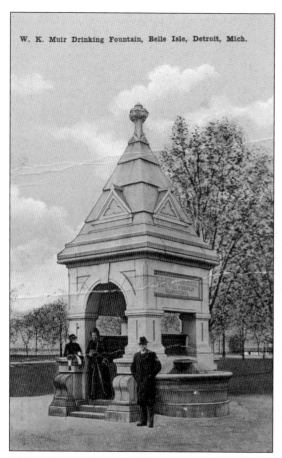

W. K. Muir Drinking Fountain, Belle Isle, Detroit, Mich.

W.K. MUIR DRINKING FOUNTAIN.
W.K. Muir made his living managing various railroads during his career and was a prominent member of Detroit society. In 1879, Mayor George C. Langdon appointed him as a park commissioner. Muir was instrumental in turning the city's newly acquired Belle Isle into a vibrant park. In 1896, a memorial fountain was commissioned in his honor. The unique design allowed for both humans and horses to quench their thirst.

DRINKING FOUNTAIN. An artistic stone drinking fountain complete with flowers and shrubs added to the aesthetic pleasure of the isle. Attention was given to detail in all aspects of park additions. Even basic utilitarian items such as drinking fountains and bridges were designed in such a way as to lend a sense of beauty and enduring quality to the island.

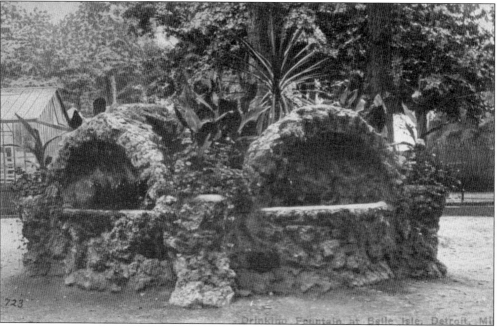

Drinking Fountain at Belle Isle, Detroit, MI

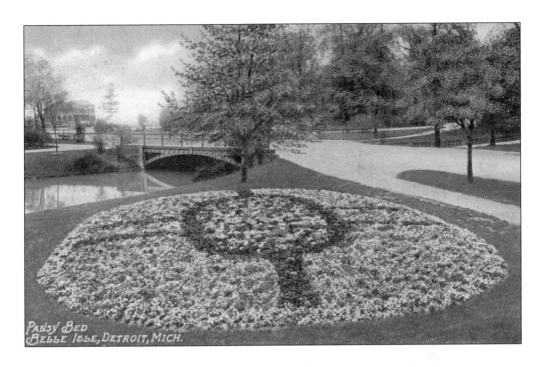

PANSY BED
BELLE ISLE, DETROIT, MICH.

LUSH LANDSCAPES. Plants were grown at the Horticultural Building (Conservatory) to supply the flowers necessary to create lush landscapes throughout the city of Detroit and its various parks. Horticulturists were hired to design intricate flowerbeds that showcased stunning pictures and designs. The American flag was showcased at the Cedar Mound, with a floral clock at the park entrance and a varying number of garden delights around the island to please the senses.

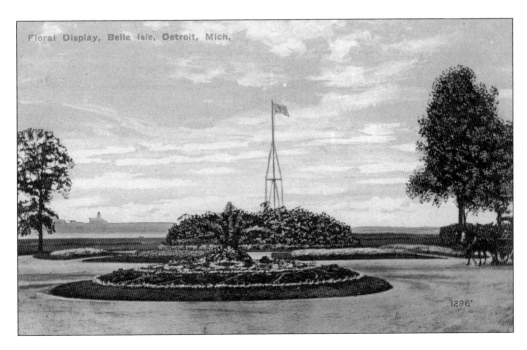

Floral Display, Belle Isle, Detroit, Mich.

1296

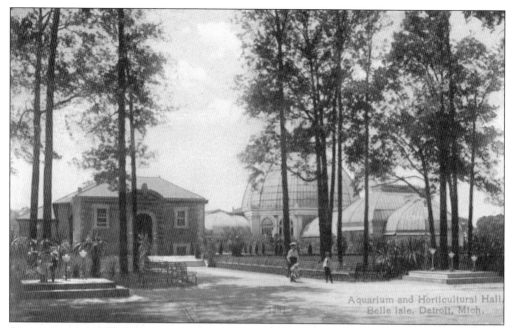

AQUARIUM AND HORTICULTURAL HALL. Summer months brought thousands of visitors through the aquarium on a regular basis. A favorite among Detroiters, Windsorites, and tourists alike, the proximity to the Horticultural Hall (later named the Anna Scripps Whitcomb Conservatory) made it an easy and pleasurable trip to take in the sights of Belle Isle.

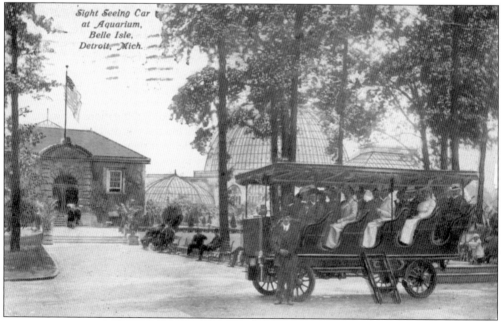

SIGHTSEEING CAR AT AQUARIUM. The 1899 park report registers the phaeton service as having carried 148,122 passengers across the Belle Isle bridge and 31,482 around the island. Park commissioner Philip Breitmeyer contracted with the Belle Isle Auto Company in 1907 to provide four 17-passenger and three 32-passenger vehicles for island use. Fares were 5¢ to the aquarium, 3¢ to the casino, and 15¢ to circle the park.

74

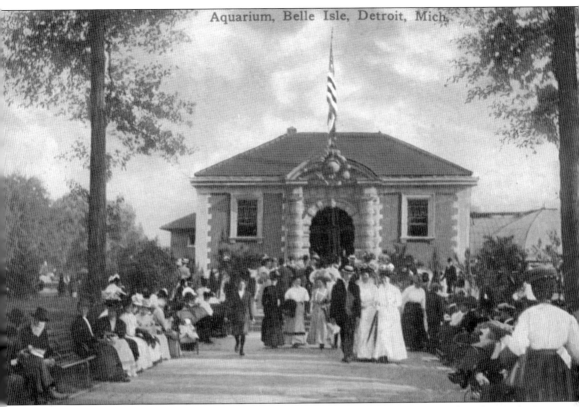

THE AQUARIUM ON BELLE ISLE. Designed by famed architect Albert Kahn, the Beaux-Arts–style aquarium was among the six largest in the world at the time of its opening in 1904 and came at a cost of $165,000. The exterior features a Baroque entrance complete with carvings of dolphins and the Roman god of water, Neptune. Above the door is the City of Detroit seal and its motto, "Speramus meliora; resurget cineribus," which translates: "We hope for better things; it will rise from the ashes." The interior sea-green glass tiles lend to the feeling of being in underwater caverns, where 44 tanks, containing a combined 6,000 gallons of water, once featured marine life from the freshwater of the Great Lakes and the salt water from the world's oceans. The tanks were designed to be featured gallery style, as if they were artwork hanging on the wall. In the mid-1950s, the aquarium underwent major renovations, and some of the original features were removed or replaced.

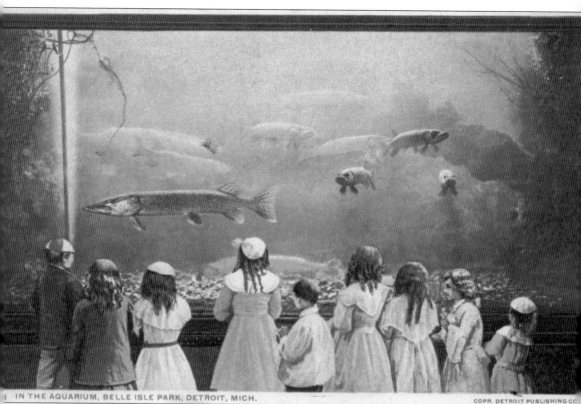

ENJOYING THE EXHIBITS. The Monday, August 8, 1904, *Detroit Free Press* reports that over 10,000 people visited the aquarium the day before, even though not all exhibits were ready. Even so, it was said that the New York Aquarium's daily attendance did not equal the number that had visited the Belle Isle exhibit, though still incomplete. An official opening ceremony was held on August 18, 1904, with over 5,000 people attending the exhibit throughout the day. The aquarium, magnificent in style and design, boasted state-of-the-art equipment to maintain the health of its marine life. The basement contained two 25-horsepower pumps with a total capacity of 108,000 gallons per hour, used for circulating hot water for heating the aquarium, conservatory, and greenhouse buildings, which required more than five miles of pipe. In addition, there were four 100-horsepower boilers, a blower for the ventilating system, a blower for draught under boilers, stokers, condenser, circulating ice drinking water pumps, and more that were required to maintain operations.

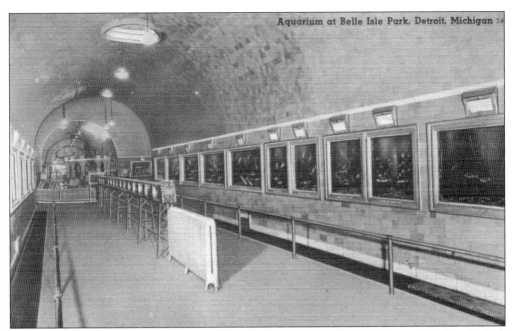

FRESHWATER FISH. The Belle Isle Aquarium once housed a collection that included every species of freshwater fish found in Michigan's lakes and streams and species from other inland waters throughout the country. In addition to the freshwater fish, there were exhibits of tropical fish, alligators, turtles, sea lions, otters, and South American beavers.

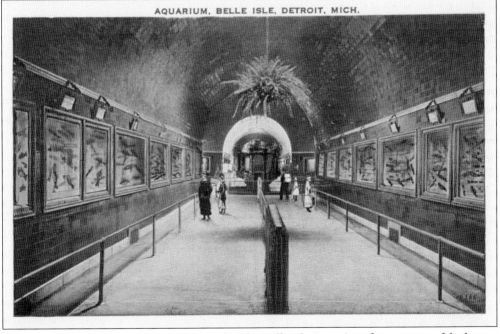

AQUARIUM, BELLE ISLE, DETROIT, MICH.

INTERIOR VIEW OF THE AQUARIUM. Today, the Belle Isle Aquarium features one of the largest collections of air-breathing fish in the world. It also features all seven species of gar known in North America. The Belle Isle Conservancy continues work to expand exhibits and preserve the great history of the aquarium.

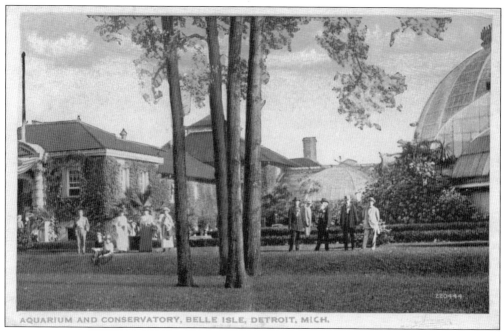

AQUARIUM AND CONSERVATORY, BELLE ISLE, DETROIT, MICH.

ENJOYING THE SIGHTS. The Belle Isle Aquarium is the oldest aquarium in the country and held the distinction of being the longest continuously operating until 2005, when the City of Detroit shuttered the aquarium against the wishes of the public. The Belle Isle Conservancy reopened the aquarium in 2012 and has worked diligently to expand operations once again.

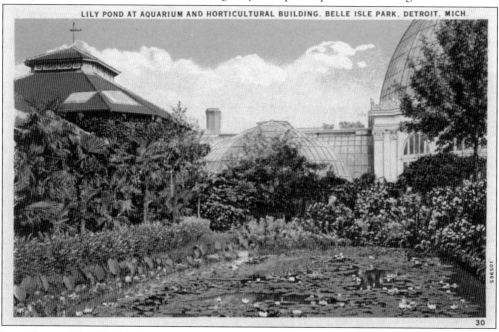

LILY POND AT AQUARIUM AND HORTICULTURAL BUILDING, BELLE ISLE PARK, DETROIT, MICH.

LILY POND. The Lily Pond was constructed between the Belle Isle Aquarium and the Belle Isle Horticulture Building (now the Conservatory) in 1936. A total of 200 tons of moss-covered limestone boulders were brought in from the Detroit River to create the walls. Today, the Belle Isle Conservancy maintains the Lily Pond, the aquarium, and the Conservatory.

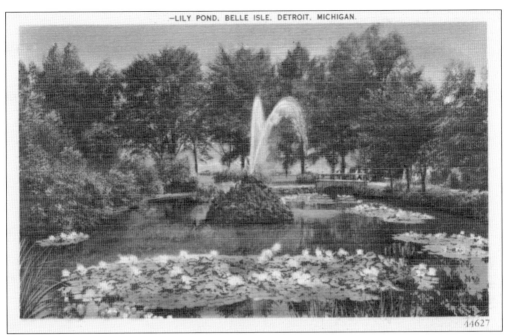

-LILY POND, BELLE ISLE, DETROIT, MICHIGAN.

44627

KOI POND. Today, the Lily Pond is known as the Koi Pond during the warmer months of the year. Each November, a "koi wrangling" is held in order to bring them in for the winter. Volunteers are eager to help with the task, and it has since become an annual event for some families.

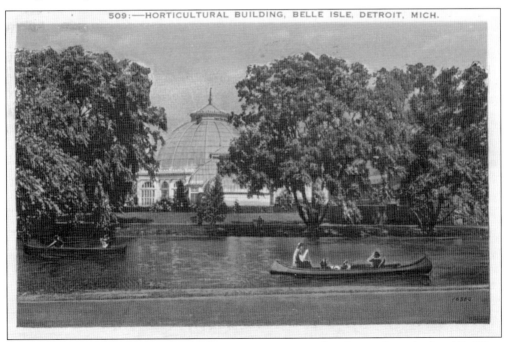

509:—HORTICULTURAL BUILDING, BELLE ISLE, DETROIT, MICH.

HORTICULTURAL BUILDING/CONSERVATORY. The Albert Kahn–designed Horticultural Building is the oldest continually run conservatory in the United States. Opening at the same time as the Belle Isle Aquarium on August 18, 1904, it quickly became a popular attraction for visitors. It is divided into five sections, each viewing area housing a different collection of plants.

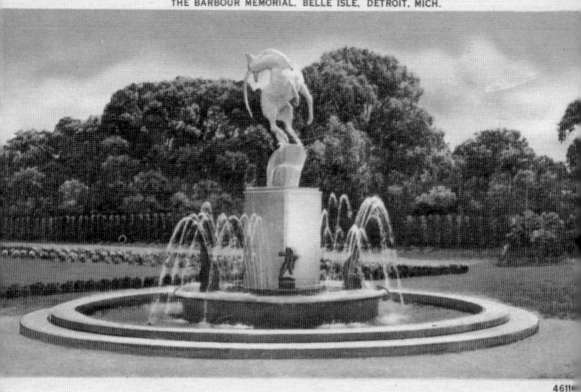

4611

LEVI L. BARBOUR MEMORIAL FOUNTAIN. Levi Lewis Barbour was a lawyer who helped with the negotiations between the City of Detroit and the Campau family for the purchase of Belle Isle in 1869; thus bringing Belle Isle back into the hands of the people. Civic-minded and devoted to enhancing Detroit, Barbour left provisions in his will to beautify Belle Isle. A competition was held for the designing of a fountain to honor him. Marshall Fredericks, an instructor at Cranbrook Institute, won the competition. A beautiful bronze gazelle graces the fountain, while its corners feature animals native to Belle Isle. The inscription at its base comes from Barbour himself and speaks to his devotion to civic affairs: "A continual hint to my fellow citizens to devote themselves to the benefit and pleasure of the public."

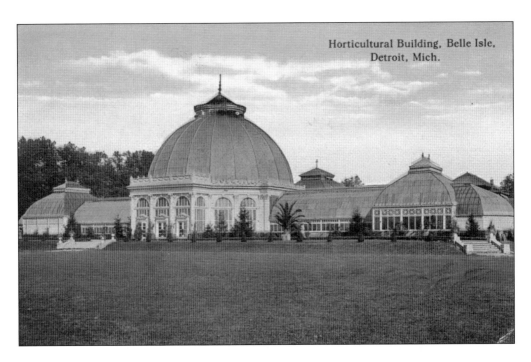

Horticultural Building, Belle Isle, Detroit, Mich.

HORTICULTURAL BUILDING/CONSERVATORY. The Horticultural Building was renamed the Anna Scripps Whitcomb Conservatory after Whitcomb donated her 600-plant orchid collection to the City of Detroit. She was the daughter of James Edmund Scripps, founder of the *Detroit News.* The name dedication service was held April 6, 1955. Renovations took place in 1949 to replace the wooden-framed dome structure with steel and aluminum The tallest dome reaches 85 feet and houses the collection of palm trees.

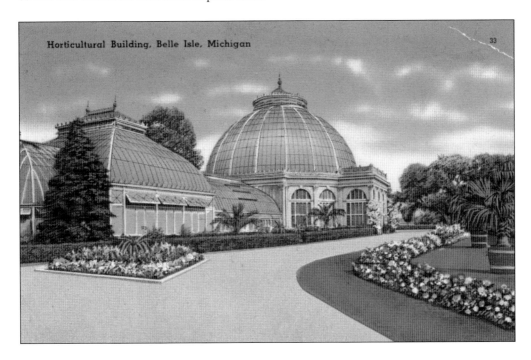

Horticultural Building, Belle Isle, Michigan

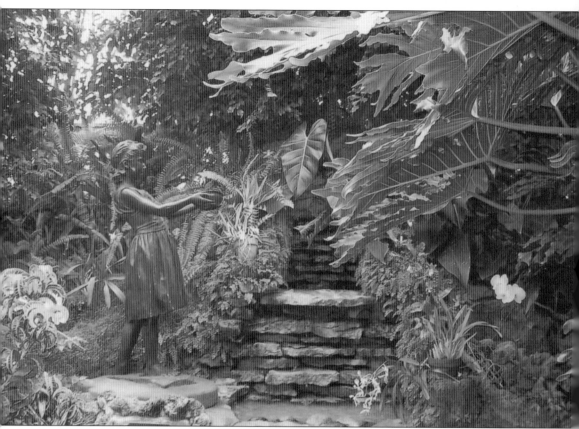

CHILDREN'S CHRISTIAN TEMPERANCE FOUNTAIN. Located inside the conservatory is this beautiful bronze monument of a little girl holding out a cup. The fountain is mounted on a granite base and bears the inscription "Children's Temperance Fountain—MCMX." The estimated cost was $2,500 and was obtained through the efforts of Elizabeth Stocking and the Loyal Temperance Legion. Funds were raised one penny at a time by the city's children as a plea for temperance. It was presented to the City of Detroit on June 14, 1910.

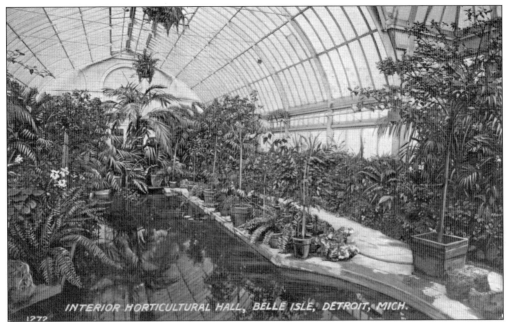

INTERIOR HORTICULTURAL HALL, BELLE ISLE, DETROIT, MICH.

TROPICAL PARADISE. When the Horticultural Building opened in August 1904, it housed many rare tropical plants. City horticulturist Robert W. Unger spent some time in St. Louis, Missouri, in October that year, in order to make further arrangements to secure cuttings and slips from which plants and foliage would be propagated during the winter and used for the beautification of the city parks and boulevards. Guests enjoyed visiting the Horticultural Building during the winter months as flowers continued to bloom and brighten long winter days. Each of the five viewing rooms showcased different plants and lent to a unique experience as one made his or her way through the greenhouses. The Horticultural Building is truly a tropical paradise.

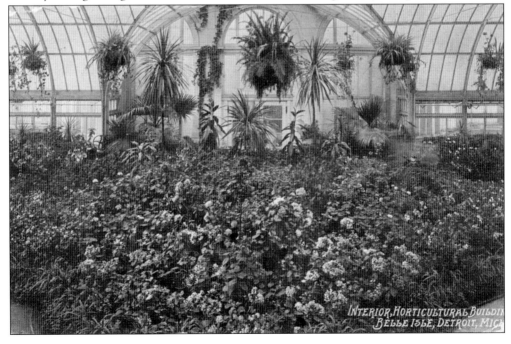

INTERIOR, HORTICULTURAL BUILDING
BELLE ISLE, DETROIT, MICH.

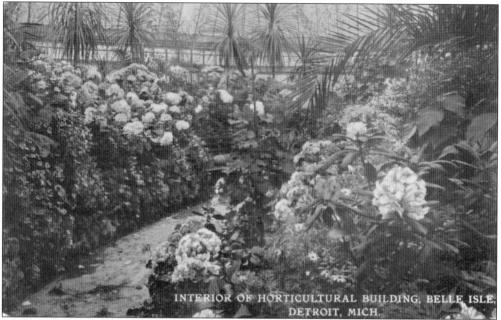

INTERIOR OF HORTICULTURAL BUILDING, BELLE ISLE, DETROIT, MICH.

ORCHIDS. The orchid house, or jewel box, as Robert W. Unger, 1904 city horticulturist, preferred to call it, started out with 80 varieties of orchids. When Anna Scripps Whitcomb donated her orchid collection in the 1950s, the conservatory became the home of the largest municipality-owned orchid collection in the country. Many of those orchids were saved from Britain throughout World War II.

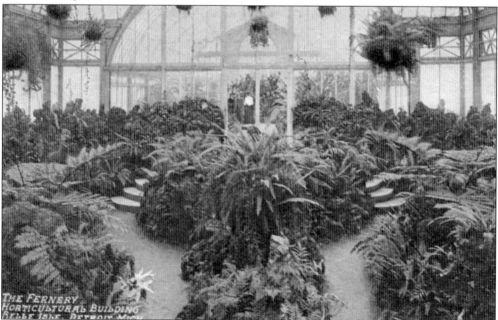

THE FERNERY. Sixty-four varieties of ferns, all coming from tropical countries, were featured in 1904. Wall space was given to the climbers, hanging baskets were suspended from the ceiling, and winding pathways banked with tufa rock provided a space for ferns to thrive. The Fernery floor is sunken in order to provide the correct climate conducive to maintaining ferns.

84

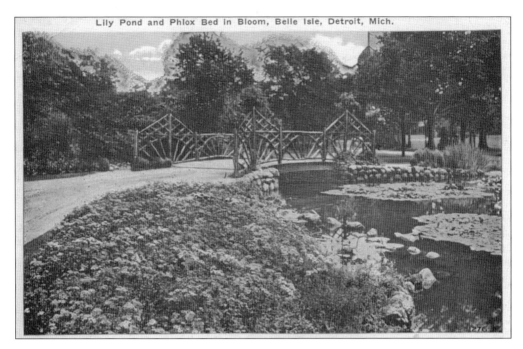

Lily Pond and Phlox Bed in Bloom, Belle Isle, Detroit, Mich.

DAY AND NIGHT AT THE LILY POND. The Lily Pond, or water garden, hosted a large variety of plants. Banked on one side were the massive leaves of the Brazilian love tree, which takes its name from its habit of clinging close to any nearby object and climbing up on it. The surface of the water was almost entirely covered with water lettuce. Scattered over the pond were several varieties of African water lilies that lift their heads in pink, blue, and white. Egyptian lotus, water poppy, water hyacinth, and a number of other plants with an occasional stately stalk of the Egyptian paper reed thrived in the water garden. Among the plants, goldfish could be seen darting back and forth. Frogs and turtles could occasionally be seen as well.

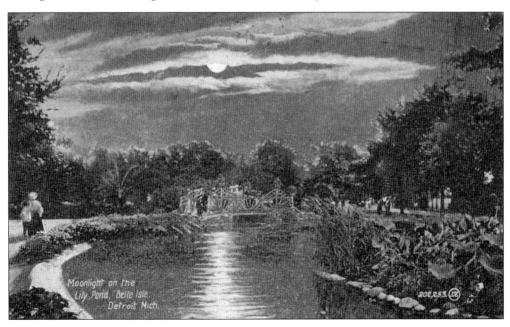

Moonlight on the Lily Pond, Belle Isle, Detroit, Mich.

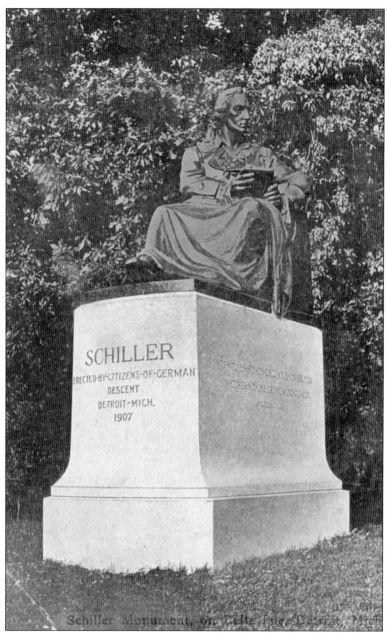

JOHANN FRIEDRICH SCHILLER MONUMENT. The German philosopher, poet, and dramatist Johann Christoph Friedrich von Schiller was born November 10, 1759, in Marbach, Württemberg (later part of Germany). Among his notable works was "An die Freude" ("Ode to Joy"), which was used by Ludwig van Beethoven in his Ninth Symphony. Detroit's German community wished to honor Schiller and commissioned this granite and bronze statue by sculptor Herman Martzen in 1907. The inscription on the side of the statue is a line from Schiller's drama *William Tell* and written in German: "Wir wollen sein ein einzig Volk von Brüdern, in keiner Not uns trennen und Gefahr.—Wilhelm Tell." An English translation of *William Tell* reveals the line to be this: "We will be a nation of united brothers, in no distress or peril will we part." The Johann Friedrich Schiller monument was placed on Belle Isle in 1909.

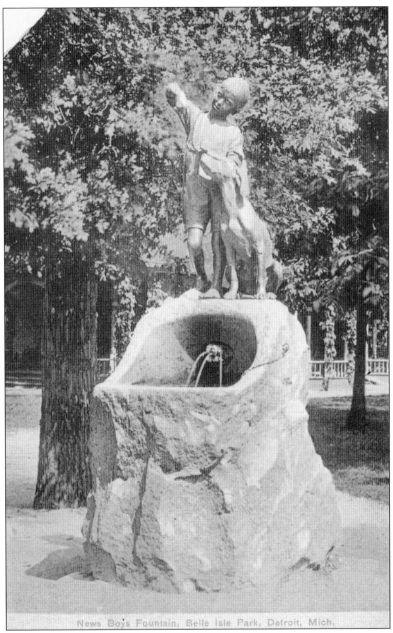

News Boys Fountain, Belle Isle Park, Detroit, Mich.

NEWSBOYS FOUNTAIN. James Edmund Scripps was the founder and publisher of the *Detroit Evening News* from 1873 until his death in 1906. Scripps commissioned this fountain in 1897 as a tribute to his faithful newsboys and their loyal canine companions who called out the headlines and distributed the news to readers across Detroit. The inscription etched into the fountain basin reads, "Partners—The Evening News to the Newsboys of Detroit." Frederick Dunbar sculpted the original statue in 1897, and it was revealed at a picnic for all the *Detroit Evening News* newsboys, of whom papers reported about 5,000 in attendance on Belle Isle. The statue was stolen but recovered by authorities in 1966; it was then stolen again in 1974 and never recovered. Sculptor Janice B. Trimpe was tasked with creating a duplicate of the statue in 1997, exactly 100 years after the original was revealed.

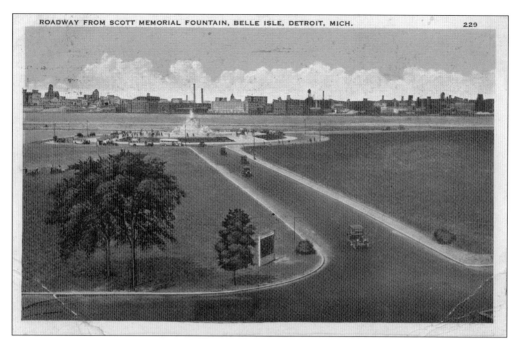

JAMES SCOTT MEMORIAL FOUNTAIN. Located on the western end of the island, the James Scott Memorial Fountain is considered the crowning jewel of Belle Isle. Scott, a Detroit businessman who died in 1910, left the bulk of his estate to the city with a directive in his will that a fountain and memorial statue be built as a gift to the citizens of Detroit. Debate raged over the gift, as Scott was not necessarily respected by several of his peers. In 1915, the island was expanded by 200 acres with dirt and rock excavated from downtown building sites, which provided a location for the fountain and lagoon. The fountain was completed in 1923 and dedicated May 31, 1925.

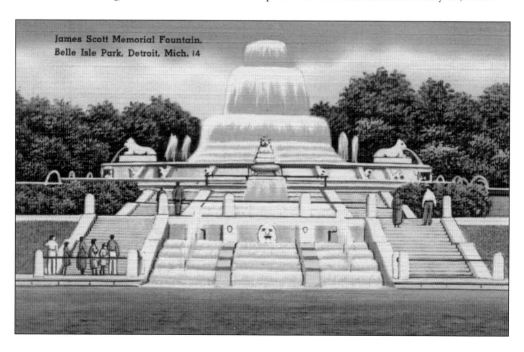

James Scott Memorial Fountain. Belle Isle Park. Detroit, Mich. 14

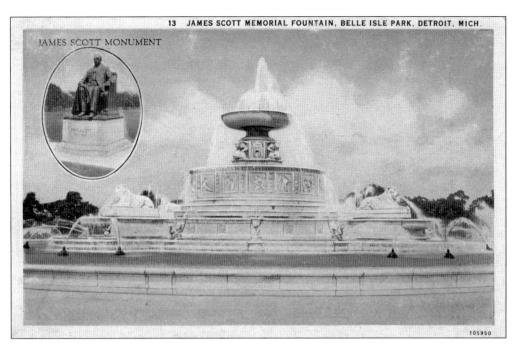

JAMES SCOTT MONUMENT

105950

JAMES SCOTT FOUNTAIN AND STATUE. Architect Cass Gilbert designed the Scott Fountain, which was completed in 1923 at a cost of $500,000. Sculptor Herbert Adams designed the James Scott statue. Cast in bronze and situated on a marble pedestal, a larger-than-life James Scott is seated in a chair overlooking his memorial fountain while facing the skyline of Detroit. Inscribed on the back of the chair is the following: "For the enjoyment of the people and for the adornment of his native city, James Scott bequeathed to Detroit his fortune to be used in the construction of this fountain erected MCMXXIII from the good deed of one comes benefit to many."

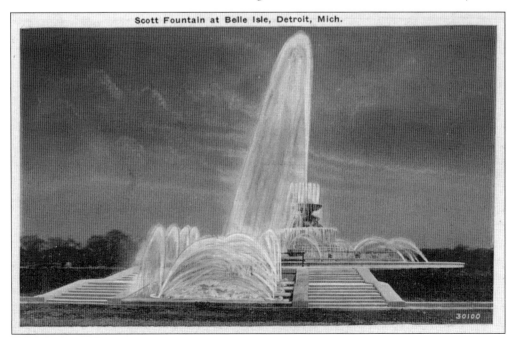

Scott Fountain at Belle Isle, Detroit, Mich.

30100

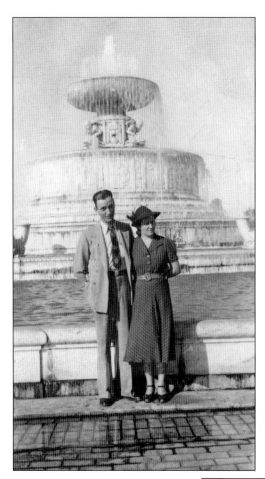

SCENIC BACKDROP. A trip to Belle Isle would not be complete without taking a picture in front of the James Scott Memorial Fountain. Couples, families, friends, and lovers have all captured magical moments at the fountain. Photographers have used this scenic backdrop for photographs on special occasions such as engagements, weddings, family reunions, proms, and various social functions.

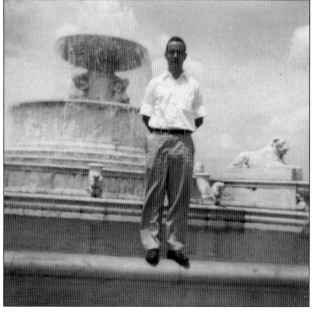

NANCY BROWN PEACE CARILLON.
Annie Louise Brown, who wrote under
the pseudonym Nancy Brown, began
writing an advice column entitled
Experience for the *Detroit Evening News*
in 1919. She became extremely popular
by sharing her experiences of life and
living in Detroit with her readers, and
intrigue followed her as neither she nor
the newspaper editors would reveal who
she was or details of her appearance. In
1936, she began encouraging readers
to donate their spare pennies to build
a Peace Carillon on Belle Isle where
the annual Sunrise Services were held.
The readership responded and the
Peace Carillon's $60,000 price was fully
funded by the generous donations of
Brown's readers.

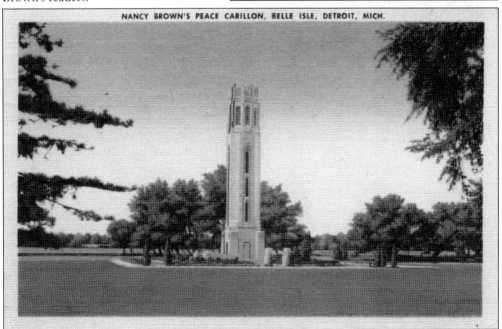

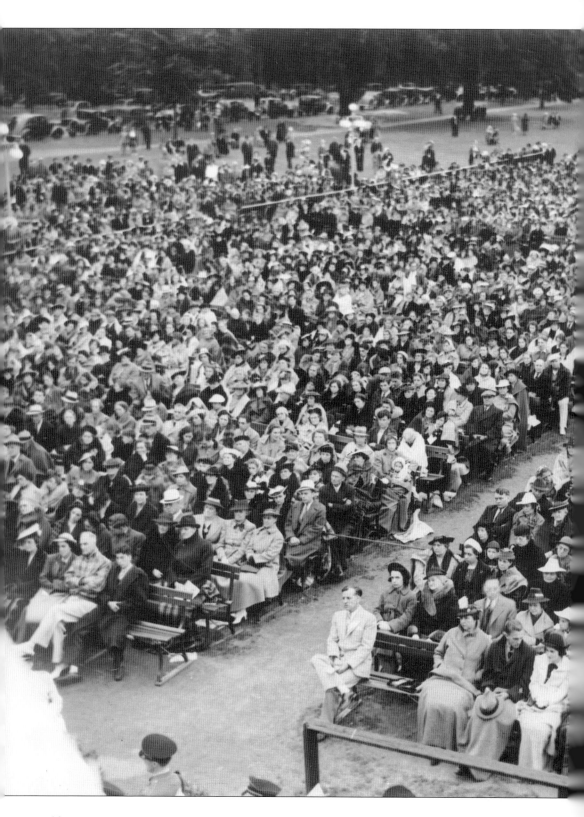

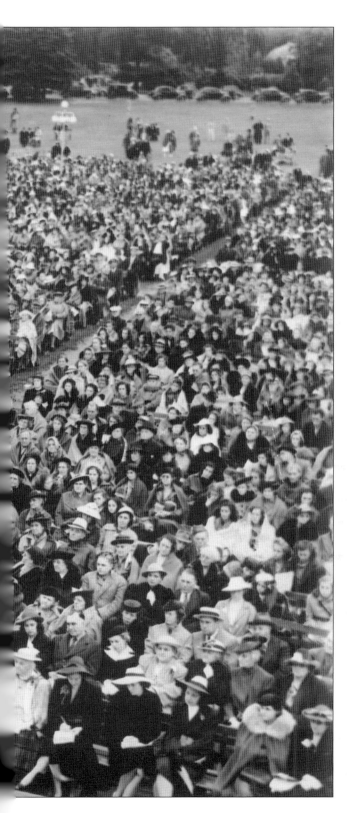

BELLE ISLE SUNRISE SERVICE.
The first Sunrise Service on Belle Isle was held at the suggestion of one of Nancy Brown's *Detroit News* readers in 1934. The Municipal Symphony Concert Shell near the Anna Scripps Whitcomb Conservatory was chosen to serve as the venue for the Sunrise Service that became an annual event drawing over 30,000 people each year. The Peace Carillon was built on that site to commemorate the services and to serve as a reminder of generosity, love, and the spirit of community that brought thousands together in a time between two world wars and during the Great Depression.

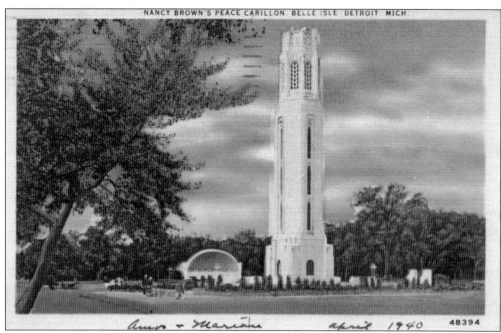

Amos + Marion april 1940 48394

PEACE CARILLON AND MUNICIPAL SYMPHONY CONCERT SHELL. Clarence E. Day, brother-in-law of James Edmund Scripps, the publisher of the *Detroit Evening News,* was the designer of the 85-foot neo-Gothic Peace Carillon. The cornerstone was laid on December 13, 1939, and features the following inscription: "Dedicated to peace in honor of Nancy Brown by readers of her Experience Column in The Detroit News. A.D. 1939." Nancy Brown finally revealed herself to her readership when the tower was dedicated on June 16, 1940, at the seventh Sunrise Service, with a crowd of over 50,000 people. The Municipal Symphony Concert Shell was the host site for weekly concerts put on by the Detroit Symphony Orchestra and many other musicians during the summer months as a place to provide accessible concerts and elevate the cultural experiences of every class of Belle Isle's visitors.

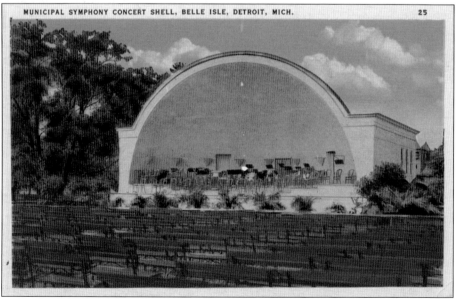

MUNICIPAL SYMPHONY CONCERT SHELL, BELLE ISLE, DETROIT, MICH. 25

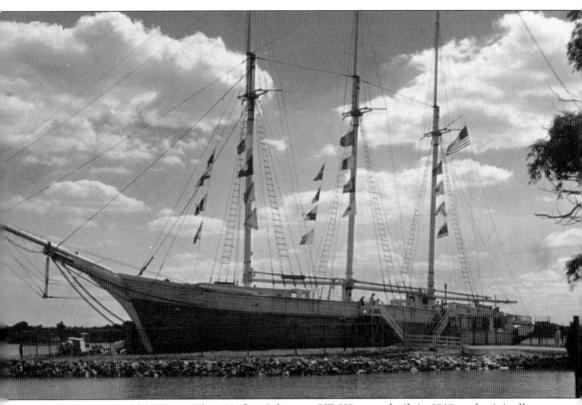

THE SCHOONER *J.T. WING*. The 140-foot Schooner *J.T. Wing* was built in 1919, and originally designed for service in the East African mahogany trade. She was originally launched as the *J. T. Webster*, and after many years of service in Africa and along the Eastern Seaboard of the United States, she was purchased by Grant H. Piggott in 1935. Piggott renamed her as the *J.T. Wing* and put her into service on the Great Lakes. Eventually, the schooner could not keep up with more modern vessels and was decommissioned as the last commercial schooner on the Great Lakes. Piggott brought the *Wing* back to Detroit in 1948, where she was dry-docked on Belle Isle and became the first home of the Museum of Great Lakes History. The museum was an instant hit among Belle Isle visitors, but out of the water, the *J.T. Wing* began to dry-rot quickly. The museum curator Capt. Joseph E. Johnston proclaimed that her seams had opened so wide, a person could "throw a cat through," and the vessel was burned in 1955.

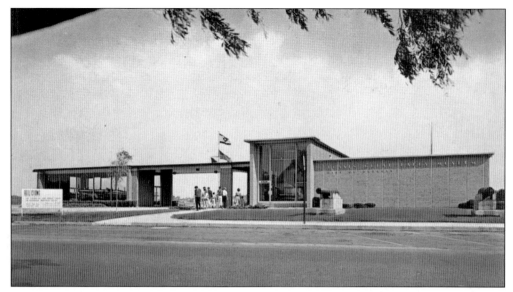

THE DOSSIN GREAT LAKES MUSEUM. After the *J.T. Wing* was razed, the Dossin family stepped forward with the initial capital to build a new Great Lakes History Museum including $125,000 for a new museum and the family's $100,000 President's Cup–winning hydroplane *Miss Pepsi.* The new Dossin Great Lakes Museum opened on July 24, 1960, on the site of the former ship–museum.

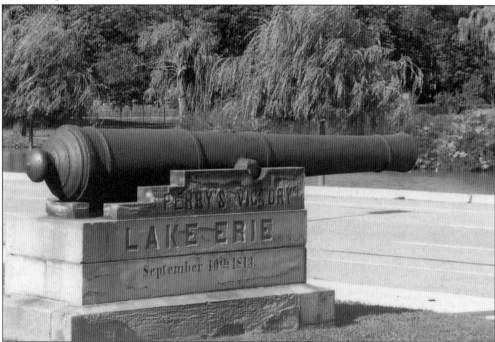

PERRY'S VICTORY ON LAKE ERIE. A pair of cannons stand guard outside the Dossin Great Lakes Museum serving as a historical monument to one of the largest naval battles during the War of 1812, the Battle of Lake Erie. Naval commander Oliver Hazard Perry led a decisive American victory over the British on September 10, 1813, securing Lake Erie for the Americans and earning him the title "Hero of Lake Erie."

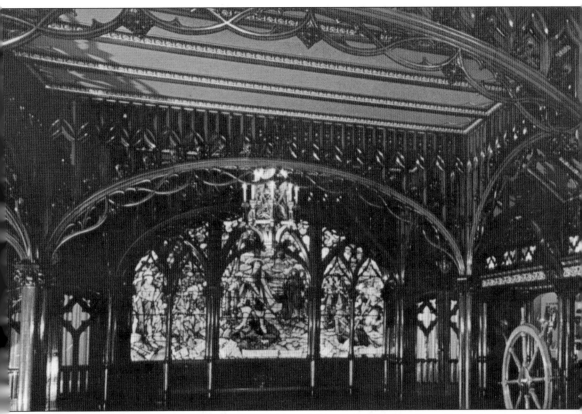

THE GOTHIC ROOM. One of the most notable exhibits at the Dossin Great Lakes Museum is the Gothic Room located in the Polk Family Hall. Stepping into this meticulously reconstructed gentleman's smoking lounge from the Detroit and Cleveland Navigation Company steamer *City of Detroit III* is meant to transport visitors back to the golden era of Great Lakes steamer travel. The room features stained-glass windows, ornate woodwork, and a window set up to look as if the viewer is seeing the Detroit shoreline at the turn of the 20th century. When the *City of Detroit III* was scrapped in 1956, this room was removed from the vessel and stored in an Ohio barn for 10 years, waiting for the right owner. Detroit citizens and maritime enthusiasts raised the money to purchase the room as a featured permanent exhibit of the *Dossin*, and volunteers put in thousands of hours of work to restore its details and ensure its preservation for years to come.

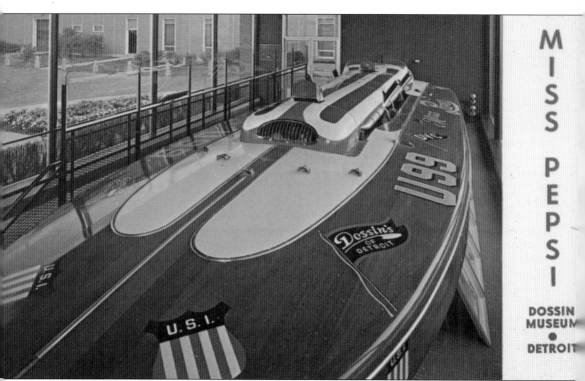

MISS PEPSI. The Dossin brothers' prized unlimited multiple-step hydroplane, *Miss Pepsi,* was part of the family's original bequest for the new Dossin Great Lakes Museum. The Dossin family owned the Detroit-based Dossin Food Products Company, which became the Michigan and northern Ohio bottler and distributor of Pepsi-Cola. As they controlled the distribution of Pepsi, their business prospered, and they saw a way to use the growing sport of speedboat racing as a tool for advertising while having some fun. The Dossins named the boat after their best-selling product, and they were off to the races. This incarnation of *Miss Pepsi* was designed by John Hacker and built in 1950 by Les Staudacher. Equipped with two airplane engines, she was the first boat to qualify at more than 100 miles per hour and won numerous races over the next few years. The *Miss Pepsi* became known as an unbeatable vessel and was retired from racing in 1954. She was presented to the museum in 1963 for permanent display.

DOSSIN MUSEUM OUTDOOR EXHIBITS. Featured among the outdoor exhibits of the Dossin Great Lakes Museum, along with Commandant Perry's cannons, are historical maritime artifacts such as a Coast Guard utility boat, the emergency steering wheel (pictured below) and propeller of the *Paul H. Townsend* built in 1945, an anchor from the schooner *North West*, a Navy submarine anchor, a 19th-century flagpole anchor, and the bow anchor of the *Edmund Fitzgerald* (pictured at right), which was lost from the ship one mile off the shores of Belle Isle in 1974. These artifacts offer visitors a sense of the scope and importance of maritime industry along the Detroit River and the Great Lakes, while the artifacts' sheer sizes put into perspective the cargo freighters and other vessels moving about the river just beyond the museum.

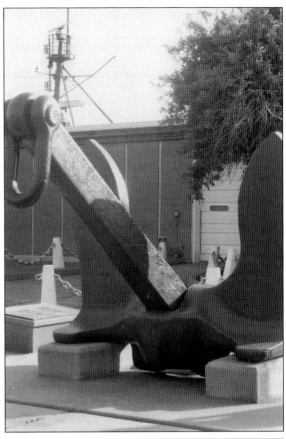

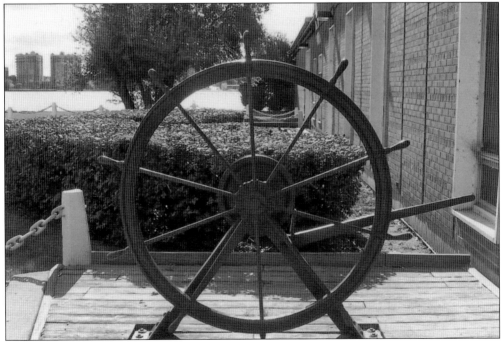

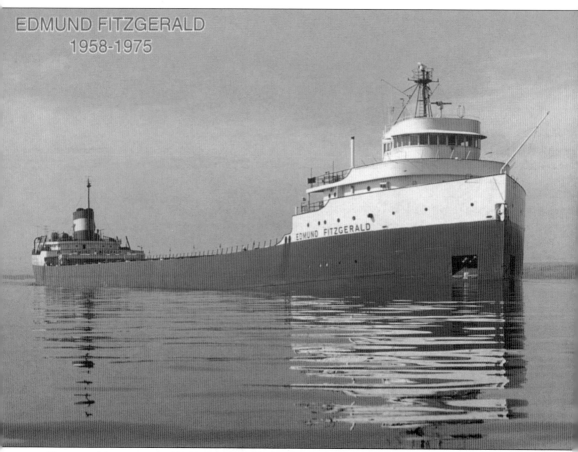

EDMUND FITZGERALD **(1958–1975).** When speaking about Great Lakes maritime history, one will most assuredly hear of the legendary *Edmund Fitzgerald*. In 1957, the Northwestern Mutual Life Insurance Company contracted with the Great Lakes Engineering Works to build the largest ship on the Great Lakes. The 729-foot vessel was built in 1958 and named for Northwestern Mutual Life Insurance Company's chairman of the board Edmund Fitzgerald. The ship had 17 years of service on the Great Lakes, before setting out on its final voyage. On November 10, 1975, the *Edmund Fitzgerald* was caught in a violent gale that had hit Lake Superior with winds to 45 knots and 30-foot seas. Last known contact with the *Edmund Fitzgerald* showed it had lost its radars, but only theories remain as to why the ship broke apart and sank, taking all 29 of its crewmen with it. The *Edmund Fitzgerald* rests 530 feet below the surface of Lake Superior, about 17 miles northwest of Whitefish Point, Michigan. Memorials at the Dossin Great Lakes Museum and the Mariner's Church of Detroit take place each year at the anniversary of the sinking.

LIGHTHOUSE AND KEEPER'S QUARTERS, C. 1912. Groundings and accidents were frequent on the dangerous shoals at Belle Isle's eastern tip, so on April 6, 1881, a 15-acre section of swampy, reed-filled marshland on the eastern side of Belle Isle was purchased from the City of Detroit for $1. A 43-feet-square redbrick lighthouse tower facing the Canadian shoreline was constructed and equipped with a fourth-order Fresnel lens, which could be seen 12 miles out. The fixed red light shone from the lighthouse for the first time on the night of May 15, 1882. A lightkeeper's quarters, surrounding retaining wall, and boathouse were built to accompany the light in 1883, and the circular oil house was added to the complex in 1891. William Anson Badger was the first Belle Isle lightkeeper, serving the Belle Isle Light for four years, from 1882 to 1886, before transferring to the Windmill Point Lighthouse.

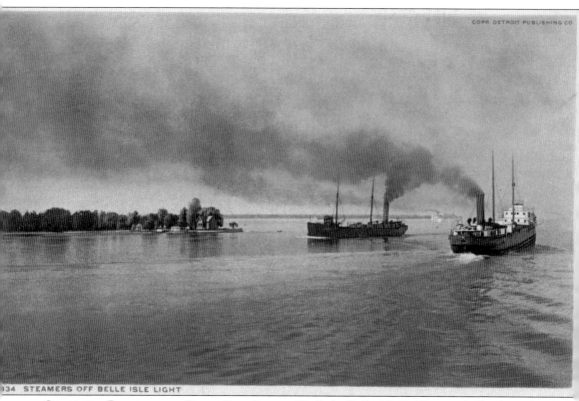

034 STEAMERS OFF BELLE ISLE LIGHT

STEAMERS PASSING THE BELLE ISLE LIGHT. Until the Belle Isle Bridge was built, the only way to access the lighthouse was by boat. The second and only other Belle Isle lightkeeper, Louis Fetes was said to have made trips into Detroit by rowing from the lighthouse to the Canadian shore, walking a few miles to Walkerville, Ontario, and taking the ferry over to Detroit. Fetes dutifully served as lightkeeper for 42 years. He brought his new bride over to the isle in 1889, and they raised their six children in the keeper's quarters while the island grew up around them. It was thought to have broken Louis Fetes's heart when the lighthouse was automated in 1929, and he died a year later in 1930, the same year his beloved lighthouse was abandoned for the taller Livingstone Memorial Lighthouse. The old Belle Isle Lighthouse was demolished in 1941 and replaced with the Belle Isle Lifeboat Station, which became Coast Guard Station Belle Isle and is fully operational today.

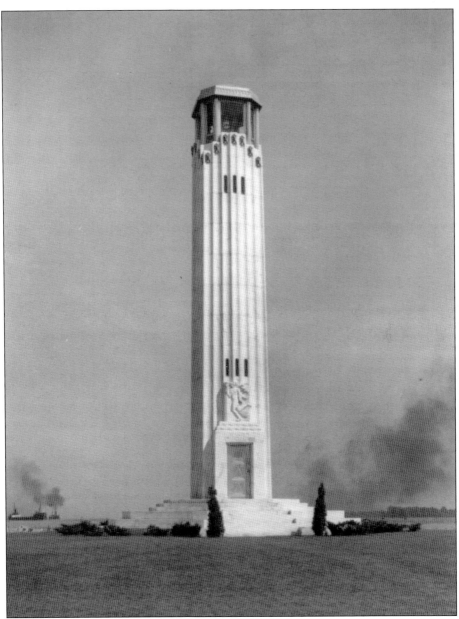

WILLIAM LIVINGSTONE LIGHTHOUSE. William Livingstone was the President of the Lake Carriers Association from 1902 until his death in 1925, and in this role, he was credited with being a fervent proponent of improvements to Great Lakes navigation, including his petition to the federal government to build the Davis and Saban locks at Sault Ste. Marie, Michigan, and deepening and widening shipping channels in the Detroit and St. Mary's Rivers and Lake St. Clair. The Livingstone channel at the mouth of the Detroit River was named in his honor. After his death, the Lake Carriers Association and the citizens of Detroit privately raised the $100,000 to extend the tip of Belle Isle and construct a memorial lighthouse honoring Livingstone's contributions to Great Lakes shipping and navigation. The design of the lighthouse was entrusted to architect Albert Kahn and it was sculpted by Gesu Maroti. The Livingstone Memorial Lighthouse was first lit on April 8, 1930.

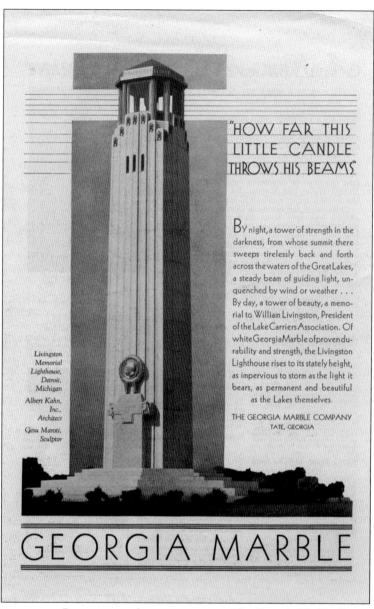

WILLIAM LIVINGSTONE LIGHTHOUSE ADVERTISEMENT. The Georgia Marble Company provided all of the Georgia white marble used in the construction of the 11-foot octagonal base and the fluted 47-foot tower, which tapers from 11 feet at the base to 8 feet at the top of the Livingstone Memorial Lighthouse. All of the marble was mined from a 5-to-7-mile marble vein in Pickens County, Georgia, and is the same type of marble used for the statue of Pres. Abraham Lincoln at the Lincoln Memorial and in the National Air and Space Museum in Washington, DC, and the annex of the New York Stock Exchange. The bronze lantern room atop the lighthouse brings the height of the structure to 70 feet tall. The lantern room was fitted with a fourth-order Fresnel lens and four auxiliary reflector lights which were powered by electric lights that had a candlepower of approximately 11,500. The light shines up to 15 miles into Lake St. Clair guiding ships safely down the Detroit River as a constant memorial to the man who devoted his years to navigation.

ROADWAY IN THE ZOO. The Belle Isle Zoo was the first of several exhibits installed on the island. In 1895, the zoo consisted of the Deer Park and a bear den; yet, by 1905, it had expanded to include 15 acres and various animals such as buffalo, eagles, owls, pheasants, ostriches, prairie dogs, and alligators. Over the years, the zoo expanded to over 30 acres and continued to be a major attraction drawing thousands of visitors each season. Management of the Belle Isle Zoo was transferred to the Detroit Zoological Park in February 1941, but by 1956, the zoo was completely dismantled due to prohibitive maintenance costs. The animals were transferred to the Detroit Zoo in Royal Oak. Eventually, a smaller zoo began operating on Belle Isle as an extension of the Detroit Zoo, much to the delight of the many visitors who frequented the park.

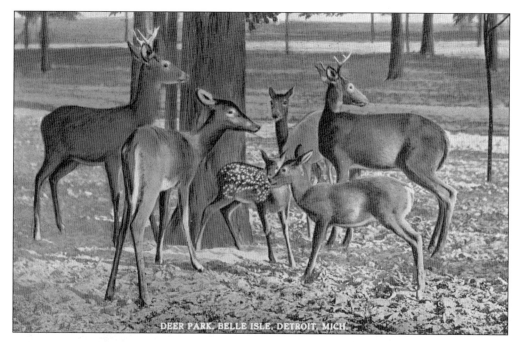

DEER PARK, BELLE ISLE, DETROIT, MICH.

DEER PARK. One of the first exhibits of the new zoo was the Deer Park. Many species were maintained over the years: Virginia, red, brown fallow, white fallow, Japanese, Sambur, Barasingha, axis, and mule deer are mentioned in some of the first reports. The annual reports give detailed information on the population of the deer herd, with births, deaths, general health, purchases, and sales being annually recorded. The deer herd eventually increased to over 400 head but was severely overpopulating the island, thereby destroying plants and causing sickness among them. Only 25 of the original brown fallow deer were kept at the Belle Isle Nature Zoo, and the others were removed.

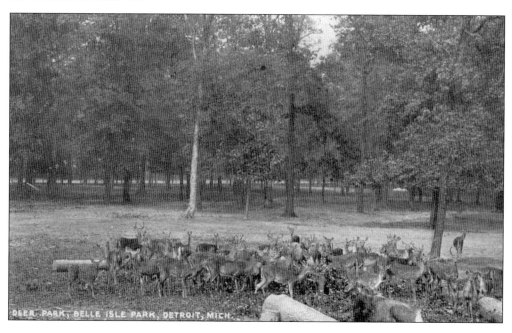

DEER PARK, BELLE ISLE PARK, DETROIT, MICH.

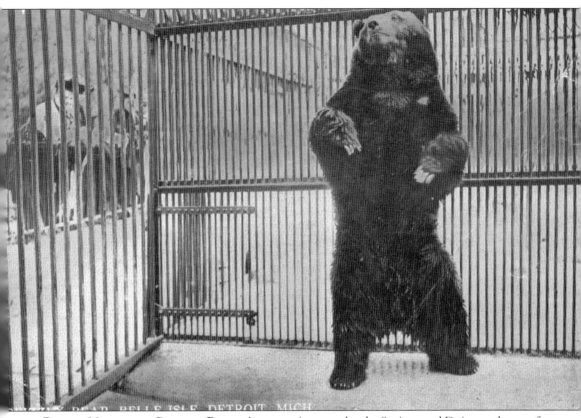

ROCKY MOUNTAIN GRIZZLY BEAR. A news snippet under the Sayings and Doings column of the *Detroit Free Press* dated May 14, 1896, indicates that the park board was obtaining a "Rocky Mountain grizzly bear" for the Belle Isle Zoo. On that same date, Sandy, the grizzly bear, joined the zoo's black bears, Don and Suzie, and their three cubs. In an article from later that year, on July 19, 1896, the zoo's bear keeper, a Mr. Leech, describes Sandy as silent and sullen, never looking up from the ground, but always looking for an escape route from his enclosure at the bear den. While Leech adored his black bears and often played with the cubs, he avoided being inside Sandy's enclosure, knowing that the grizzly would not be as docile as the other bears.

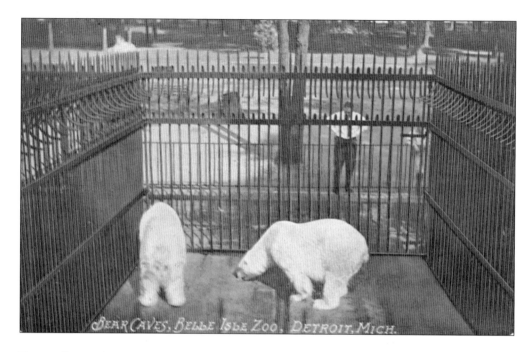

POLAR BEAR CAVES. On May 31, 1896, the *Detroit Free Press* reported that negotiations were in progress to secure a polar bear for the Belle Isle Zoo. Already in the zoo's possession were a pair of black bears with three amusingly playful cubs and one grizzly bear keen on finding an escape route. The zoo continued to make improvements while consistently expanding in size during its early years. In 1900, a pair of polar bears from Siberia was purchased by the park board for $600. With the addition of the polar bears, the bear dens on Belle Isle were soon one of the most sought-after attractions at the zoo and on the island.

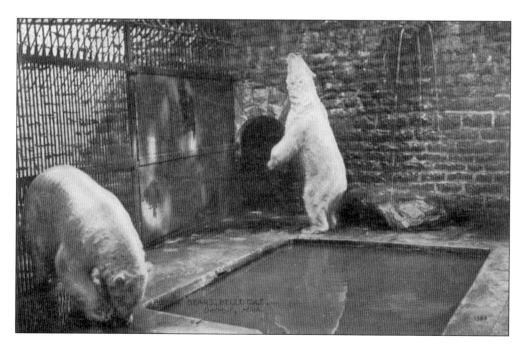

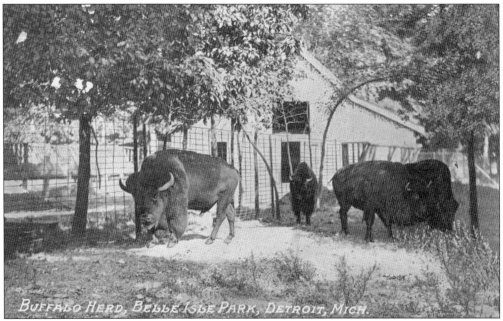

BUFFALO HERD, BELLE ISLE PARK, DETROIT, MICH.

BUFFALO HERD. In 1896, two American bison, or American buffalo, were purchased in Lincoln, Nebraska, and added to the zoo exhibitions. The *Detroit Free Press* included an article on June 13, 1898, to mark the occasion of Belle Isle's first bison baby being born on Memorial Day; "The new baby's life is one of luxurious ease. He has no keeper, for Mother Bison's temper has not been at its best for the past few days, to bother him and insist on his eating food that he doesn't want . . . In a few months if both survive, there will be two buffalo parks at Belle Isle. Few babies of the species are so fortunate as to be born at all nowadays, much less to be born on Memorial Day, and this one should be seen during his first few weeks of precocious infancy to be appreciated."

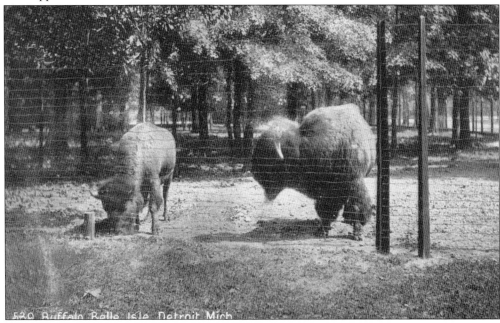

530 Buffalo Belle Isle Detroit Mich

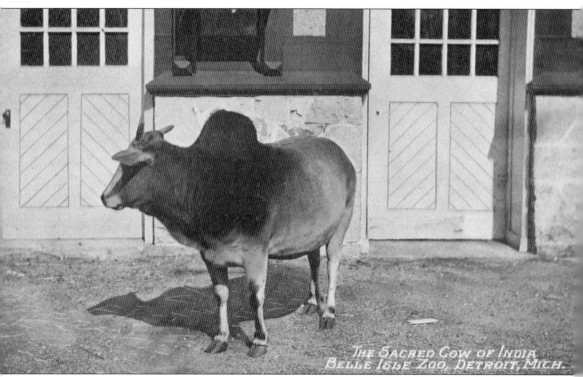

THE SACRED COW OF INDIA. It was announced by the *Detroit Free Press* on May 23, 1900, that the Belle Isle Zoo would be acquiring a pair of zebu cattle. Zebus are thought to have originated from the ancient and extinct Indian aurochs (wild cattle) in South Asia. They characteristically have humps on their backs, large dewlaps, and droopy ears. At the time the zoo acquired these zebus, a great emphasis was put on the zebu being considered sacred and worshipped because many practitioners of Hinduism have considered cows to be sacred and respected because they give life-sustaining milk. Newspaper photographers descended on the zoo in August 1909 to photograph the animals for a feature, but the article proclaimed the animals to be rather uncooperative, and the zebu in particular to be sedate as it "stood by and watched the proceedings without declining to evince the slightest enthusiasm, and taking it all as a matter of course." The Belle Isle Zoo was in possession of three zebus by 1918.

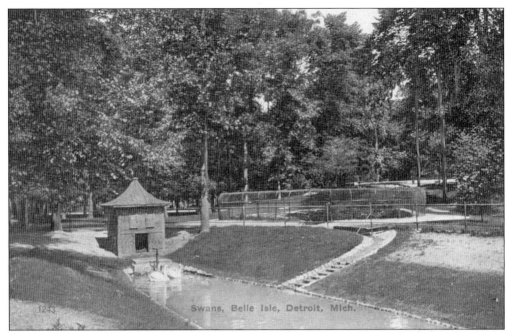

SWANS. Swans have inhabited Belle Isle perhaps longer than most other species. Native American tribes called the island Wahnabezee, or "Swan Island," and swans have been seen on and around the island ever since. The swan enclosure at the zoo featured a canal for paddling fed by a pond just uphill as well as an enclosed shelter for the swans.

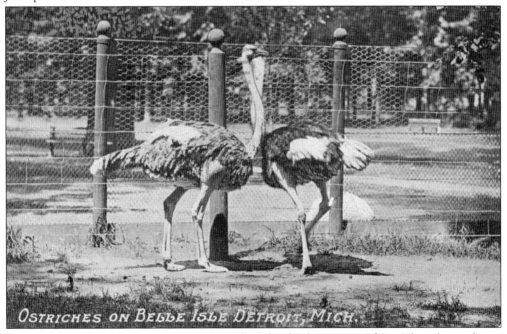

OSTRICHES. The common ostrich is a large flightless bird native to Africa. Though very large, the ostrich can run up to 43 miles per hour. In September 1897, Belle Isle was awaiting the return of its ostriches from "playing an engagement at the Boston chutes." Once their contract was fulfilled, the ostriches would return to a new exhibit arena suitable to their unique needs.

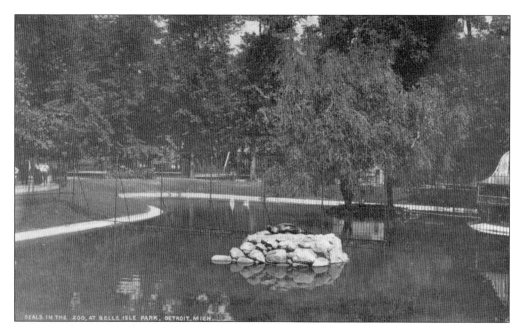

BELLE ISLE SEAL POND. Pinnipeds, or seals, were one of the most visited features of the Belle Isle Zoo for many years. One of the canals that ran through the zoo was fenced off, and a seal pond was created with a rock island for the seals to enjoy in the middle. A favorite pastime of zoo visitors was to watch the keepers feed the seals fresh fish. Seals are considered to be semiaquatic marine mammals, as they prefer to spend most of their time in the cold water, but also come onto the land to mate, give birth, molt, escape from predators, or simply to sun. Seals prefer colder water, so the seals at the Belle Isle Zoo were surely some of the animals to best adapt to Michigan winters.

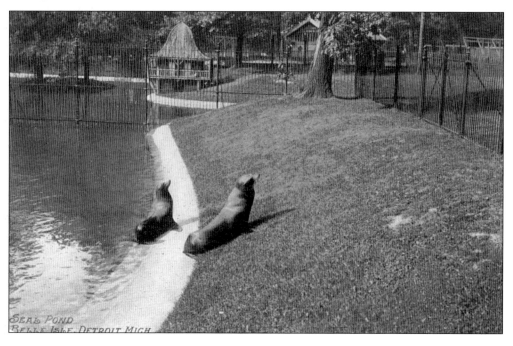

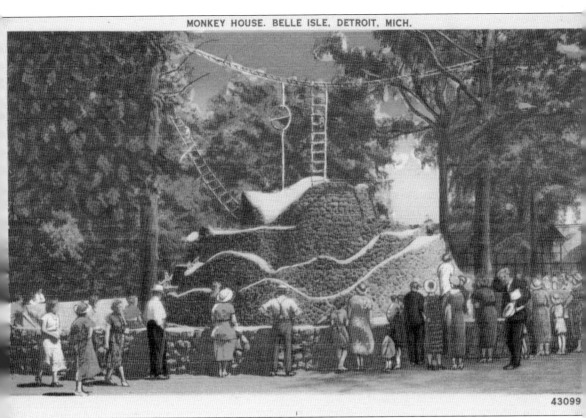

43099

MONKEY BUSINESS. Detroit businessman Aaron DeRoy gifted the Belle Isle Zoo with 25 monkeys to inhabit the new monkey exhibit that was completed in 1934. The monkeys had been captured in the jungles of India and transported to the United States. Upon being let out of the cage that they had lived in for most of their lives, the monkeys seemed unsure of what to do. Jack Ireland, curator, deemed them too civilized after watching them attempt to climb the trees only to fall. Angry, Ireland declared, "We'll have to un-civilize them!" Ladders and catwalks were installed to aid the monkeys, but ultimately, the problem was solved when Aaron DeRoy ordered 25 "instructors" to teach the monkeys the skills they were lacking. The monkeys were quick learners and were soon climbing the trees and swinging on the ropes, while amusing their guests with their antics.

Chimpanzee Theatre in Zoological Park. Detroit. Mich. 16

BELLE ISLE CHIMPANZEE SHOW.
Congo and Suzie were two of
the beloved chimpanzees that
entertained the crowds at the Belle
Isle Chimpanzee Theatre in the early
1940s. Congo was a two-year-old
chimp when he completed his first
season at the theatre in 1941. He was
described as friendly and playful, could
ride a bike and fire engine, and walk
a tightrope. Suzie was a seven-year-
old chimp at the time and performed
with Congo in two shows daily during
the season. It was believed that Congo
would surpass the famous chimpanzee
Joe Mendi in his skill and popularity.

THE CHILDREN'S ZOO AT BELLE ISLE. The storybook-themed petting zoo was built in 1947 with funding provided by the James and Lynelle Holden Foundation. James S. Holden was a native Detroiter, a lawyer by trade, and was a member of the zoo commission since its creation in 1924. It was his vision to provide a fun and entertaining environment for children to interact with animals that they would not normally have a chance to see up close. This popular exhibit provided easy access for children to have contact with the animals maintained on Belle Isle. In 1955, a new 2,600-seat amphitheater and great ape exhibit was constructed at a cost of $650,000, with funding being provided by the Holdens. James attended every preopening event (held each year for special guests prior to the main opening day of the season) up until his death one month before the preopening in 1967.

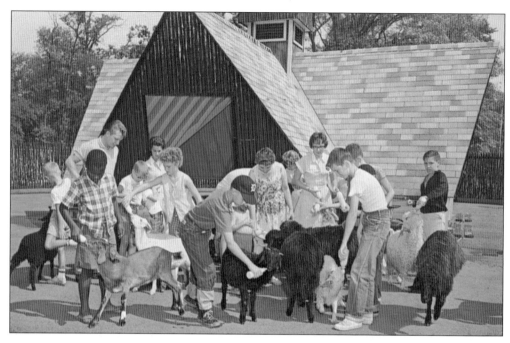

FEEDING TIME. Heidi and her kids were especially enduring to the children who ventured into the goat exhibit with bottles ready at feeding time. Keeping with the storybook theme, Heidi (the goat) was named after the lead character from the book *Heidi* by Swiss author Johanna Spyri. Heidi (the goat) also had kids named after some of the goats in the book: Schwanle, Barle, and Schnecki. The storybook–themed zoo sparked the imaginations of young and old alike and integrated educational opportunities across various subjects. Nursery rhymes and stories came to life at the zoo and perhaps enticed children to read more about the subjects they encountered.

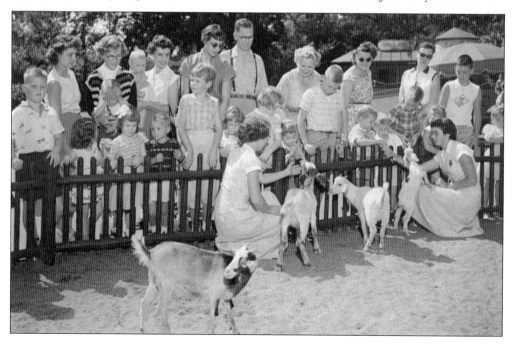

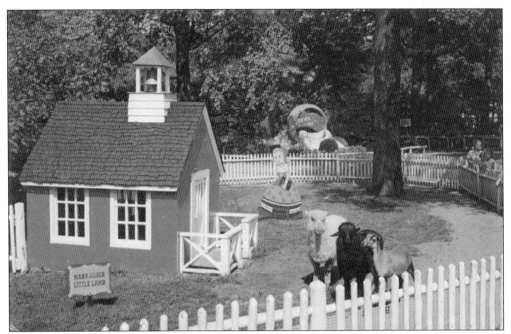

PETTING ZOO. Unlike a regular zoo, the Belle Isle Children's Zoo allowed children to get close to the animals and interact with them. Zookeepers were always on hand to keep both children and animals safe and occasionally lend a hand when an unruly goat decided to pull a sneak attack on an unsuspecting visitor by chewing on his or her clothes.

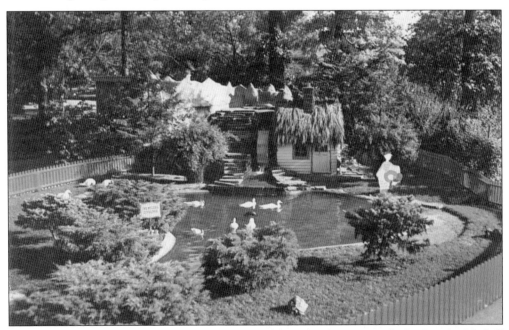

THE MERRY MILLER. This exhibit was based on the book *The Merry Miller* by Rosalys Haskell Hall. Showcasing the mill and pond made it an ideal setting for waterfowl and pond dwellers. Ducks paddled around, while turtles sunbathed on the grass. Penguins also took up residence at the mill, but they seemed a little out of place with the surroundings.

"THERE WAS AN OLD WOMAN WHO LIVED IN A SHOE." This popular nursery rhyme came to life at the Belle Isle Children's Zoo while featuring the ever-popular guinea pigs. Known for their docile nature, guinea pigs are low-maintenance, friendly, and responsive to handling and feeding, thus making them a popular household pet. With their ability to procreate rapidly, it was only fitting that they were featured in the "There was an Old Woman Who Lived in a Shoe" exhibit.

"MARY HAD A LITTLE LAMB." The lambs went to school everyday at the Belle Isle Children's Zoo. Mary kept a watchful eye on the lambs while in the schoolyard. Children were able to interact with the lambs and stop by the little red schoolhouse during their visits. The beloved nursery rhyme became even more enduring after a visit to the school yard.

Four

THE PARK SYSTEM

Belle Isle is the undisputed crown jewel of Detroit's parks, but there are plenty of other parks within the city that have served and continue to serve the citizens of Detroit. Throughout the years, some parks gave way to city expansion, others diminished in size, and new parks were developed. With over 300 parks, the City of Detroit has maintained green space for the betterment of all of its citizens. The earliest reports from the commissioners of the Department of Parks and Boulevards, Detroit, Michigan, date back to 1890, and each year, a detailed report was presented. These reports go beyond basic data to reveal the grand plans of a vibrant city known for its beauty and attention to detail.

DETROIT PENNANT. From inner-city green spaces like Campus Martius and Grand Circus Park to neighborhood parks like Clark Park and Palmer Park, Detroit has always embraced the need for leisure and recreational spaces. Today, the Department of Parks and Recreation continues a legacy of service to the citizens and guests of Detroit.

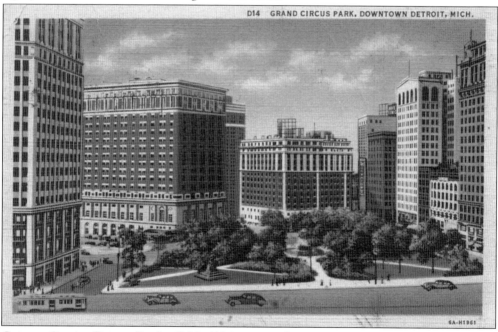

GRAND CIRCUS PARK. On April 21, 1806, an act of Congress authorized the governor and judges to re-plat the city after its destruction by fire, and their plan included Grand Circus, Capitol, and West Parks. However, no appropriation for park work was made until 1853 and then only for Grand Circus. In 1854, the expenditure was recorded and thus began the Detroit park system.

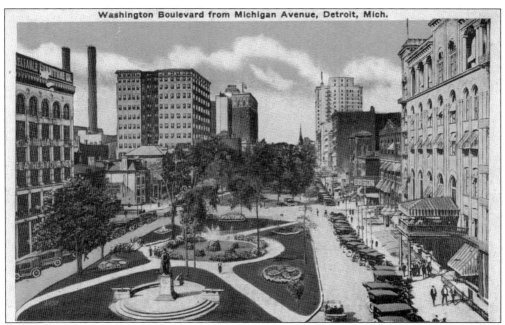

WASHINGTON BOULEVARD. Washington Boulevard's green space included various trees, fragrant and colorful flowerbeds, walkways, park benches, and a statue of Gen. Alexander Macomb, a hero in the War of 1812, looking north on Washington Boulevard. General Macomb's family owned a great deal of real estate including much of Macomb County, Belle Isle, and Grosse Ile. He joined the US Army in 1799 and became a brigadier general.

Clark Park, Detroit, Mich.

CLARK PARK. Clark Grove, a 46-acre tract of land located on the southwest side of Detroit, was owned by John P. Clark, a prominent businessman. Upon his death in 1875, he left half of the 46 acres to the City of Detroit, on the condition that the city buy the remaining acreage from his heirs. The 46 acres was secured and developed into Clark Park.

Scene at Palmer Park, Detroit, Mich.

PALMER PARK. In 1893, US senator Thomas Witherell Palmer donated 140 acres of land to be used as a city park with the condition that the existing forest be preserved. The park was eventually enlarged to 296 acres and included, among other things, hiking and biking trails, a man–made lake with a lighthouse, and a casino.

Log Cabin, Palmer Park, Detroit, Mich.

PALMER PARK LOG CABIN. Situated near the bank of Lake Francis in Palmer Park is a rustic cabin that was commissioned by Thomas Palmer as a gift for his wife, Lizzie, in 1885. The architectural firm of Mason and Rice designed a rustic log cabin that would provide Lizzie with the peaceful retreat she desired. The cabin was finished in 1887 and was known as the Font Hill Log House.

PALMER PARK SPANISH BELL. A gift to Senator Palmer from a few of his friends, the 1,015-pound Spanish bell was designed and cast in Spain in 1793 by Paula Gomez. From there, it was taken to Mexico over 200 years ago. Upon receiving such a generous gift, Senator Palmer gave it to the City of Detroit as a gift for all to enjoy.

Liberty Bell, Palmer Park, Detroit, Mich.
1378①

GLADWIN PARK/WATER WORKS PARK, ENTRANCE. The waterworks plant was situated on 110 acres of land between Jefferson Avenue and the Detroit River. The city's water commissioners decided to open the grounds to the public in the form of a park. A popular fishing spot, it soon featured swimming and picnic areas, playground equipment, and baseball diamonds. The park continued to expand services, and by the 1900s, it featured two islands, a lagoon, and a canal for canoe rides.

Driveway, Gladwin Park, Detroit, Mich.

THE FLORAL CLOCK OF GLADWIN PARK/WATER WORKS PARK. The floral clock was originally located at Water Works Park on Jefferson Avenue. Designed and built by Elbridge A. Scribner in 1893, the clock was by 1934 going to be thrown away. Henry Ford rescued and restored the clock and featured it at Greenfield Village. In 1989, the clock was returned to the city and eventually ended up on Belle Isle.

Lake at Gladwin Park, Detroit, Mich.

GLADWIN PARK/WATER WORKS PARK. A design competition was held to draft the center water tower of the waterworks plant. Detroit architect Joseph E. Sparks won with his Victorian tower with Oriental minarets. The water tower doubled as an observation tower, where visitors could climb the 202 winding iron steps to the balcony for a bird's-eye view of the Detroit River and the cityscape.

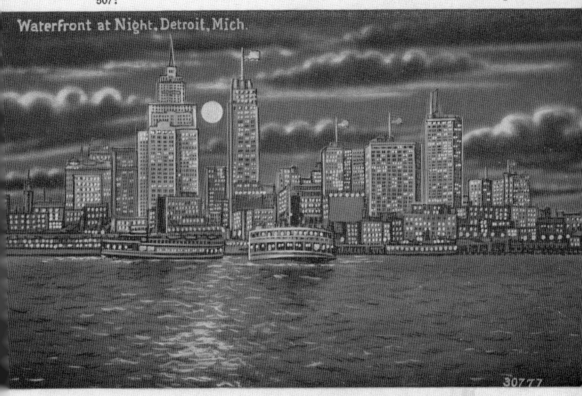

507:

Waterfront at Night, Detroit, Mich.

30777

WATERFRONT AT NIGHT. At the close of this book, it is only fitting to showcase the magnificent waterfront by moonlight. The Detroit River and Lake St. Clair form an aqua park that continues to host boat races, fishing derbies, canoeing and kayaking, and pleasure boats for dining and dancing. Detroit remains a vibrant city of rich history and great promise.

BIBLIOGRAPHY

Belle Isle Conservancy, Detroit, Michigan. (belleisleconservancy.org)

Bentley Library, University of Michigan. Ann Arbor, Michigan. (bentley.umich.edu)

Burton, C.M. *The City of Detroit, 1701–1922.* Chicago: S.J. Clarke Publishing, 1922.

Detroit: America's Most Beautiful City. Detroit: S.H. Knox & Co., 1917.

Detroit City Controller. *Annual Report of the Controller of the City of Detroit, Michigan.* 1911.

Detroit Department of Parks and Boulevards. *Annual Report of the Department of Parks and Boulevards, City of Detroit, Michigan.* 1897, 1899, 1902, 1907, 1908, 1911, 1916.

Detroit Historical Museum, Detroit, Michigan. (detroithistorical.org)

Detroiter, vol. 7.

Northwestern Reporter, vol. 157. St. Paul, MN: West Publishing Company, 1916.

Olmsted, Frederick Law. *Belle Isle: After One Year.* Brookline, MA: self-published, 1884.

Palmer, Friend. *Early Years in Detroit.* Detroit: Hunt & June, 1906.

INDEX

DISCOVER THOUSANDS OF LOCAL HISTORY BOOKS FEATURING MILLIONS OF VINTAGE IMAGES

Arcadia Publishing, the leading local history publisher in the United States, is committed to making history accessible and meaningful through publishing books that celebrate and preserve the heritage of America's people and places.

Find more books like this at
www.arcadiapublishing.com

Search for your hometown history, your old stomping grounds, and even your favorite sports team.